The Railroad and the Art of Place

The Railroad and the Art of Place

photography and text / David Kahler, FAIA

with additional essays by
Jeff Brouws and Scott Lothes

Center for Railroad Photography & Art
Madison, Wisconsin

The Railroad and the Art of Place
Copyright © 2016 David Kahler
ISBN 978-0-692-74877-0

This publication has been made possible
through the generosity of the Kahler Family
Charitable Fund.

Book design and composition by:
For A Small Fee, Inc. / Jeff Brouws & Wendy Burton
Editing: Wendy Burton & Alexandra McKee
Printing: Verona Libri, Verona, Italy

Published by:
The Center for Railroad Photography & Art
313 Price Place, Suite 13
Madison, Wisconsin 53705
www.railphoto-art.org.

for Cynthia Wagner Kahler

The Railroad and the Art of Place

David Kahler, FAIA

THE ART OF PLACE IN THE WESTERN WORLD can be traced through the mediums of painting and literature. Traditionally culture-rich cities such as Paris, London, New York or Rome are where we go to seek aesthetic satisfaction. But there are exceptions. One mysterious, compelling anomaly is the cold, stark mountainous strip found along the southern edge of West Virginia that is contiguous with eastern Kentucky. Here can be found a humble stage where human will and machines either work heroically together or brutally clash in the vestal forests. In the early 90's I came to the realization that I have always been fascinated by the art of place. It has forever been in my soul. It was rooted in my love for railroads and the landscape as long as I can remember. Later in life I learned that I could capture the essence of this dichotomy through photography.

For many decades I unconsciously harbored this passion without giving it artistic expression. Then, in 2014 I read *The Machine in the Garden* by Leo Marx. Twenty-four years earlier I had found an article in the Sunday edition of the *New York Times* that highlighted the opening of a show in a Manhattan art gallery showcasing a collection of black and white photographs of steam locomotives working the night shift by O. Winston Link. The images were created in the coal mining areas of Virginia,

West Virginia, and Tennessee. In particular, his West Virginia images caught my attention. By coincidence, the confluence of both of these discoveries would eventually set me on a new course to capture the essence of the art of place on black and white film along the mainline of the Norfolk and Southern Railway in the hallowed hills of West Virginia.

In 1992, my wife and I arrived in Williamson, West Virginia. It was the first of six week-long forays during the month of February when the weather could be rambunctious and the features within the landscape tableau were most clearly defined. Leafless trees seen against beds of snow elevated the degree of contrast thereby revealing the structural essence of each tree while adding an essential dimension of scale. As a photographer I was a novice. Armed with the best of intentions and my newly acquired second-hand Leica M6 camera I was ready to photograph black locomotives and rolling stock under the bleakest conditions— no artificial staging of thundering trains as they passed my camera. My mission was to create an artful, yet honest rendition of the changing face of this beloved industrial landscape that was being reshaped rapidly by political and market forces embodied in the guise of creative destruction. Promises were being made by powerful voices in the US Congress that by tearing down the

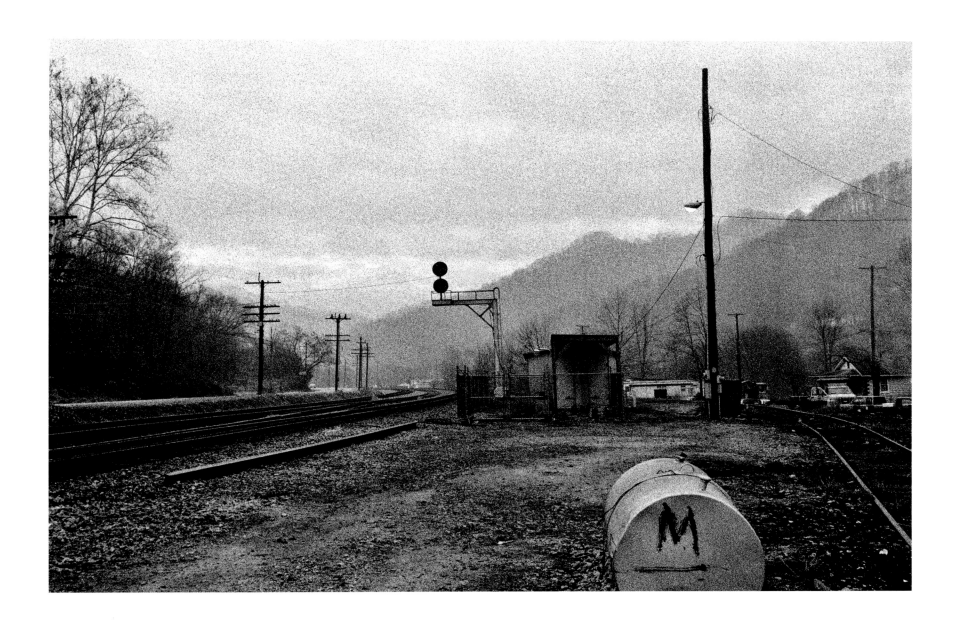

Old and replacing it with the New, better living conditions and increased accessibility within this geographically inaccessible place would be guaranteed. Sooner rather than later, narrow two-lane highways, mine runs, mine tipples, and modest miners' housing that collectively supported the coal mining machine would be only a memory.

At the same time, I was confident that my many years as a professional architect, together with three years as an instructor of a basic design course at the university level had given me a unique foundation of seasoned values and skills to look through a camera lens from a distinctly different point of view. I have loved railroads since 1937, the year that I was born. I have been sensitive to their context instinctively. My father worked for the DuPont Co. Consequently, we moved around the northeast often and frequently visited my grandparents in Harrisburg, Pennsylvania, where my grandfather had a fifty-year career on the Reading Railroad. An awareness of the human condition came naturally to me because I saw what many of my friends did not see. I was blessed with a keen power of observation. I learned to draw. I absorbed a healthy awareness of the attributes of an almost mystical environment during my early formative years when I lived in Wyeth country in southeastern Pennsylvania.

My parents were not wealthy but managed to carry our family through the end of the Great Depression and the Second World War without undue stress. I played in the fields and woodlands around Chadds Ford, the 1777 site of the Battle of Brandywine. The net result was a love for steam trains, history, art, and a sense of place.

After multiple visits to my parents' home in western North Carolina that began in 1967, a profound appreciation for all things southern was planted in my heart. The south is where my favorite authors had resided: William Faulkner and Carson McCullers. This new avenue of interest prompted me to search for the art of place in a particularly desolate corner of land in West Virginia where the railroad—the perfect personification of the machine aesthetic—either adapted to or changed the morphology of the garden with its endless network of steel rails. This epiphany appealed to my artistic sense.

Williamson, West Virginia, the most prominent railhead along the Pocahontas Division of the Norfolk Southern Railway, was a starting point. I went there originally to photograph only trains but soon became more interested in railroads and their relationship to place. Here could be found the rumble of slow-moving coal trains blocking vehicular traffic, the noise of banging railcar couplers

and backyards cluttered with detritus. Thousands of descriptive words could be saved if photographic images were produced judiciously. At the time I considered this to be a Shangri-La, where trains passed under our hotel window every twenty minutes, 24/7, during the bleakest time of the year. Black and white photographic opportunities were everywhere. It was at this juncture that I learned that photographs of moving trains were not everything. Some of the most evocative visual images could be made without rail activity. A poignant sense of emptiness that prevailed at a particular moment could be captured and transformed into artful expression if I focused my camera on the tracks and trackside structures that defined a place. As a result, lighting and composition became everything to me. More often than not they became the cardinal elements of my vocabulary of art and photography.

Several annual visits were required before I fully realized the hidden beauty and vibrancy of life that lay below the veil of gloom and loss prevalent amongst the hills and hollows along the tracks. Each annual visit conjured up the same question: how could these sturdy people maintain their sanity when wages were low and the threat of unemployment constantly hung on their weary shoulders, while a caravan of dark clouds hovered above or between bare mountain tops? Ironically, their quiet determination transmitted a message of unrelenting dedication to their own self-preservation, regardless of the hardships at hand. Their strength bolstered my spirit and spurred me on to return and stay the course to search for the art of place when many around me would consider my endeavors to be a waste of time. I learned to love detritus that I found along the railroad right of way. Many unwritten stories called to my imagination. They appeared in back alleys, byways slick with snow and ice, freezing rain, abandoned automobiles and appliances scattered around dwellings, and workers struggling with their daily commitments on the railroad. Pure poetry at its finest—the language of the misbegotten. In retrospect, it was a transformative experience for me to discover paradise lost in a desecrated wilderness. My journey began with my love for the railroad and ended with a new respect for a timeless triad: man, machine and his garden.

Pennsylvania 1951

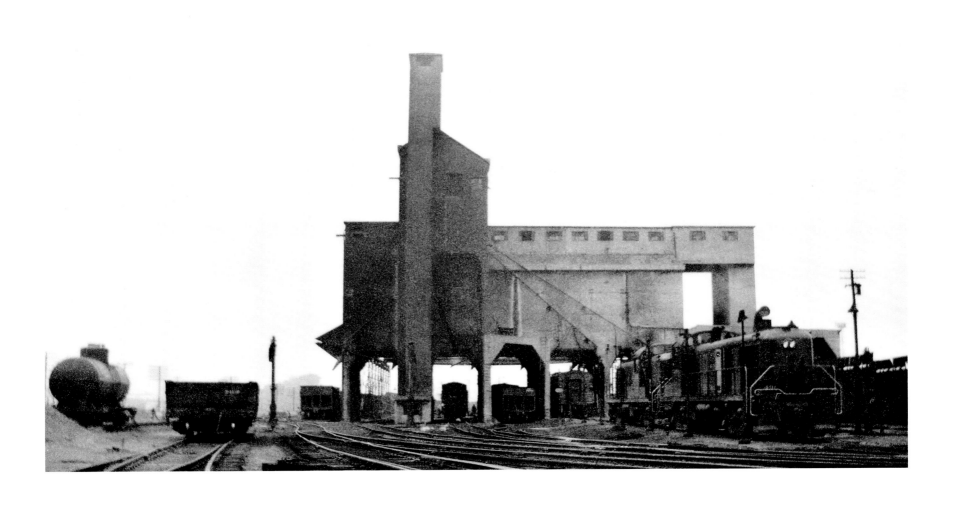

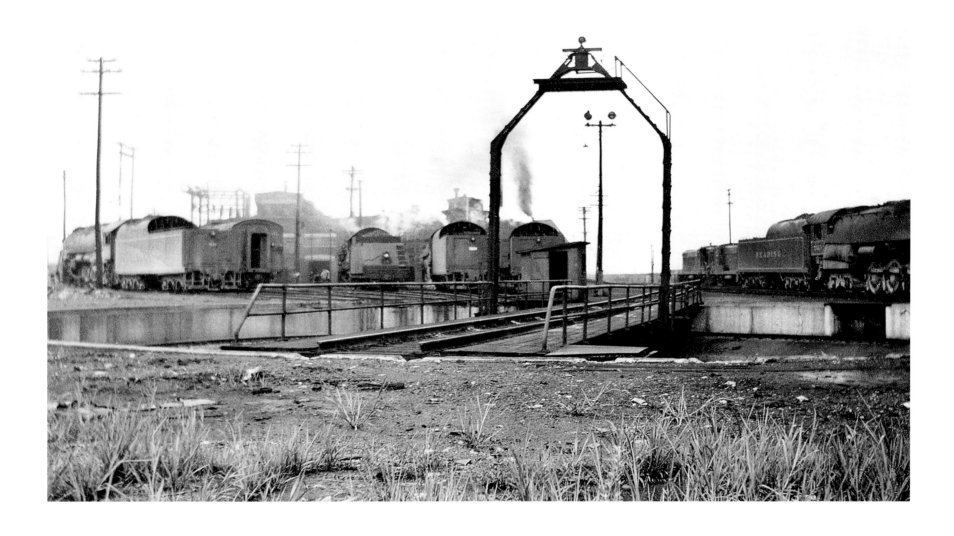

New York 1957

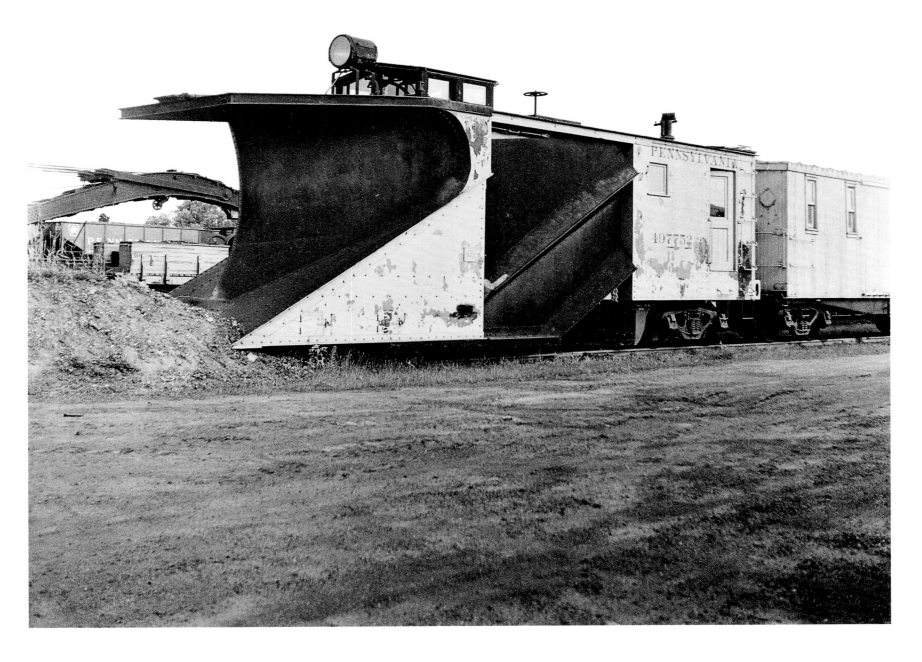

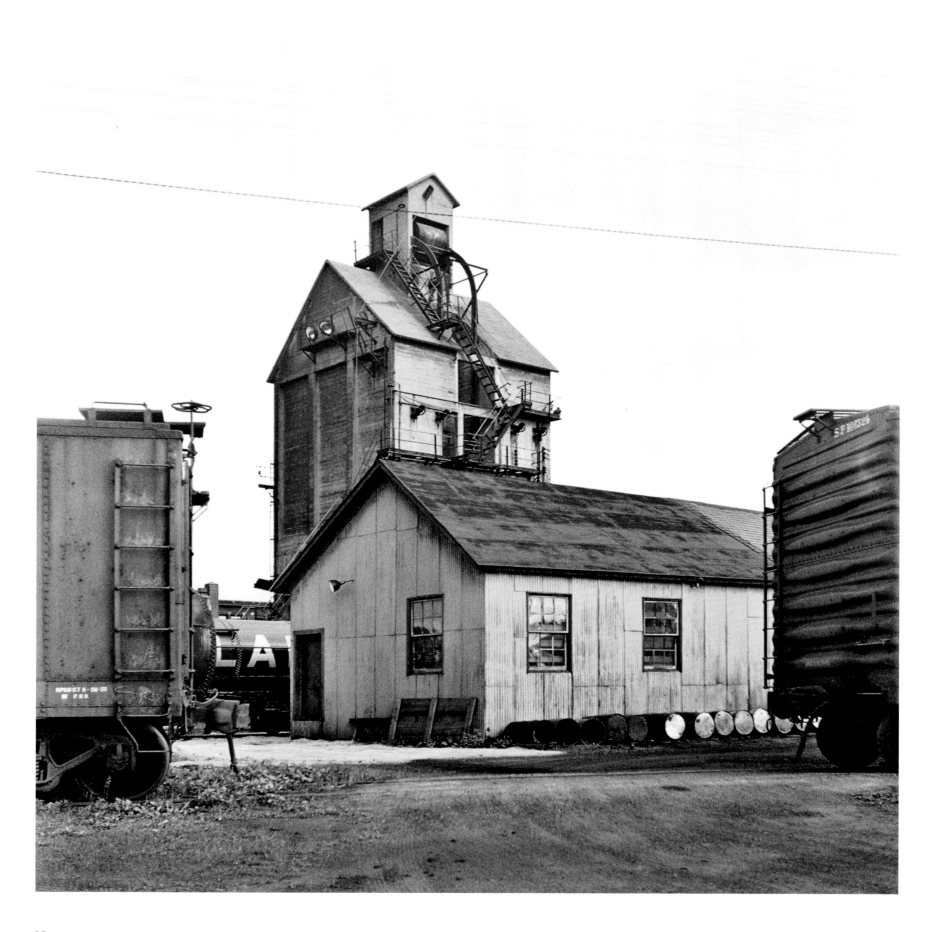

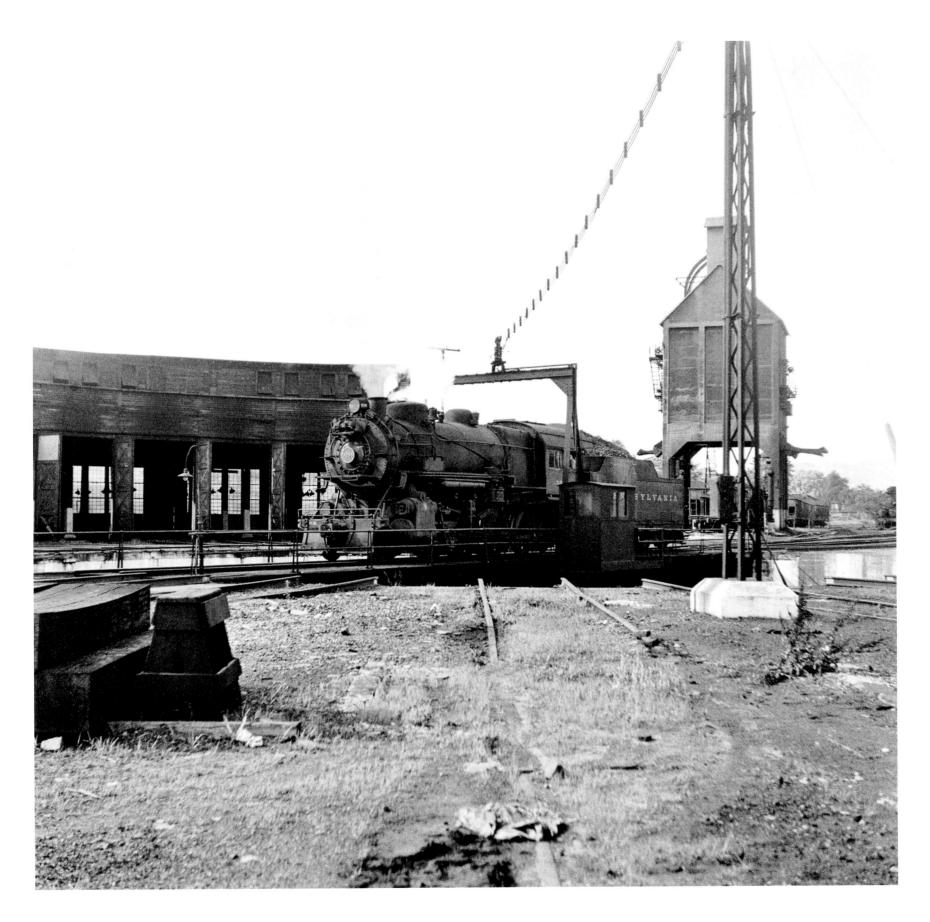

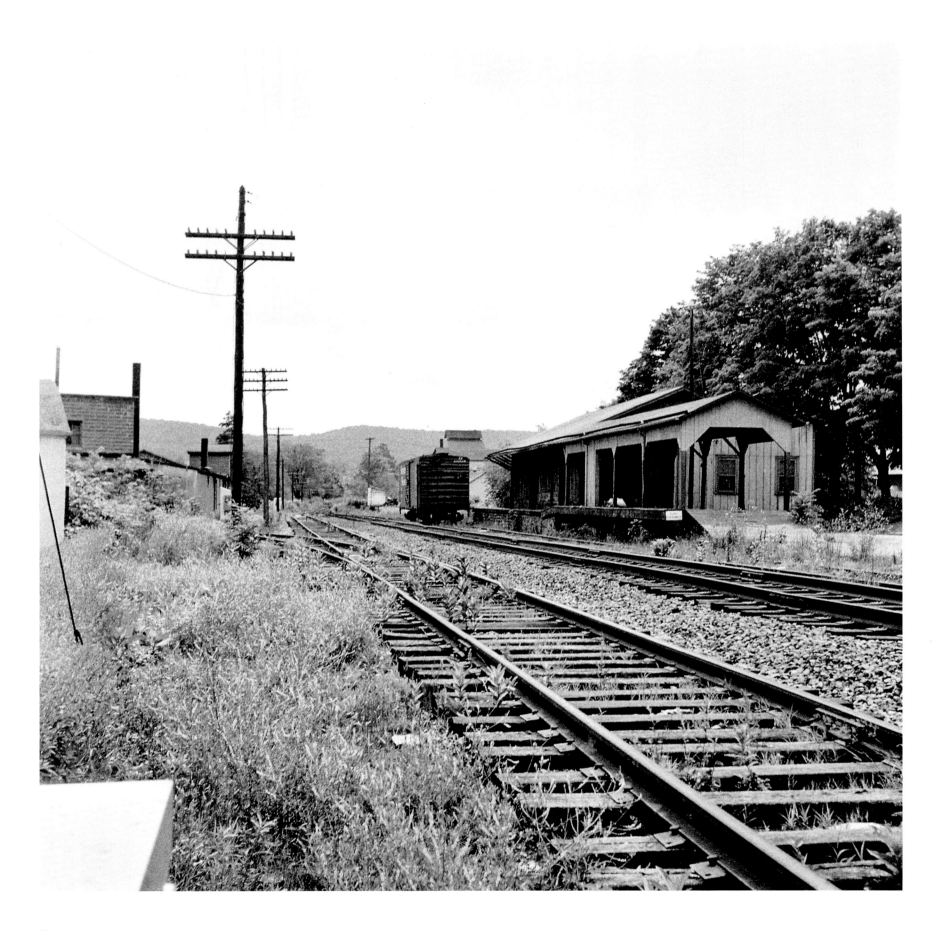

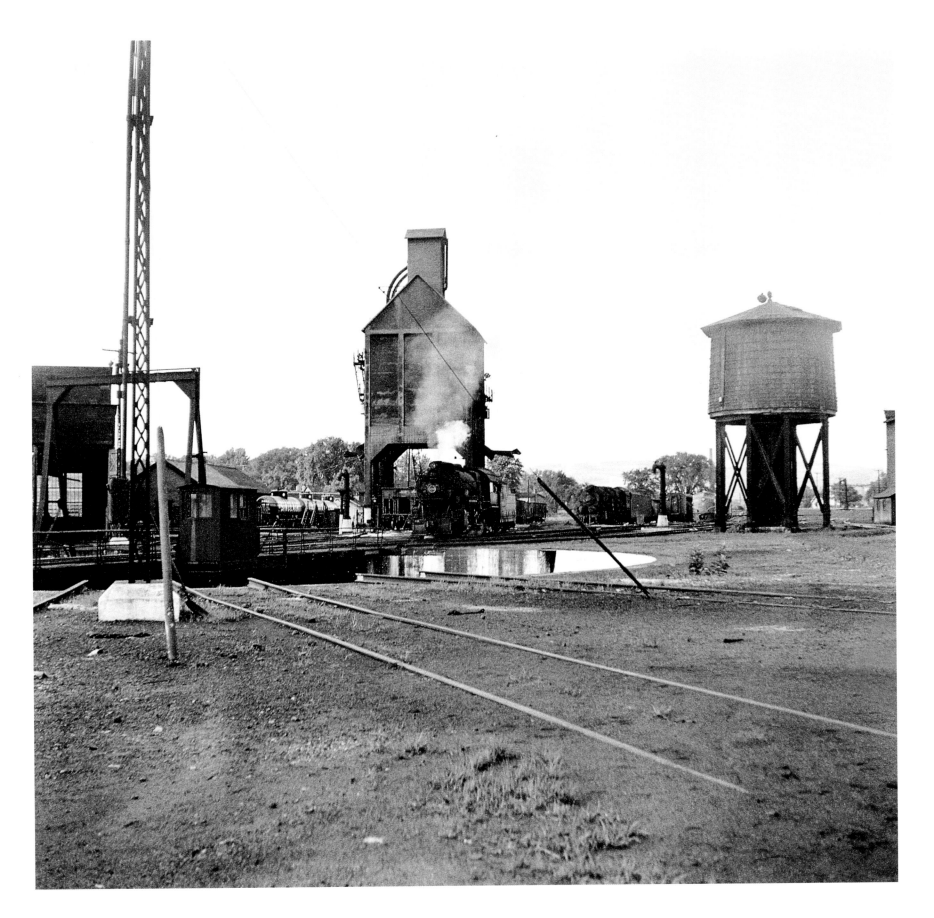

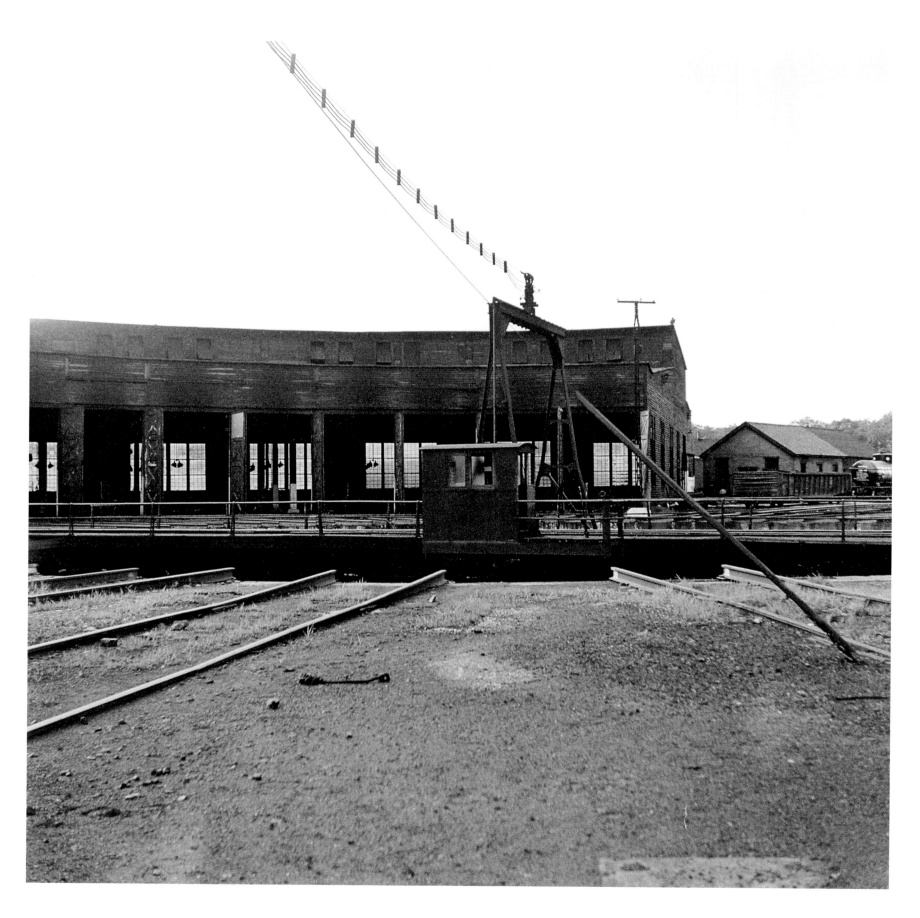

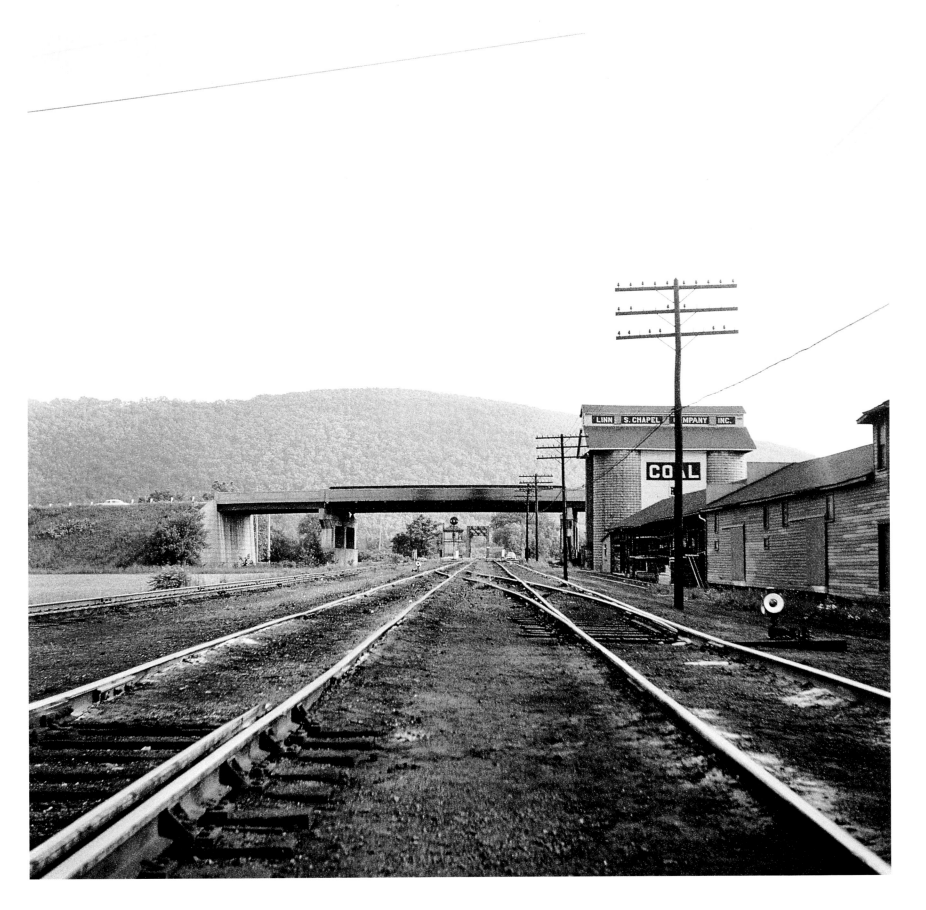

Kentucky / West Virginia 1992-1997

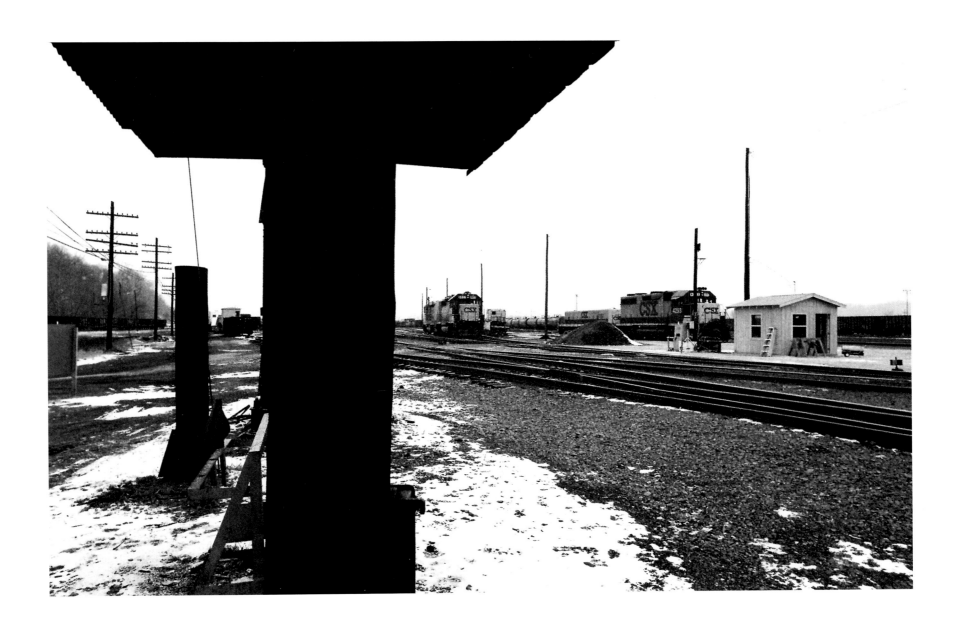

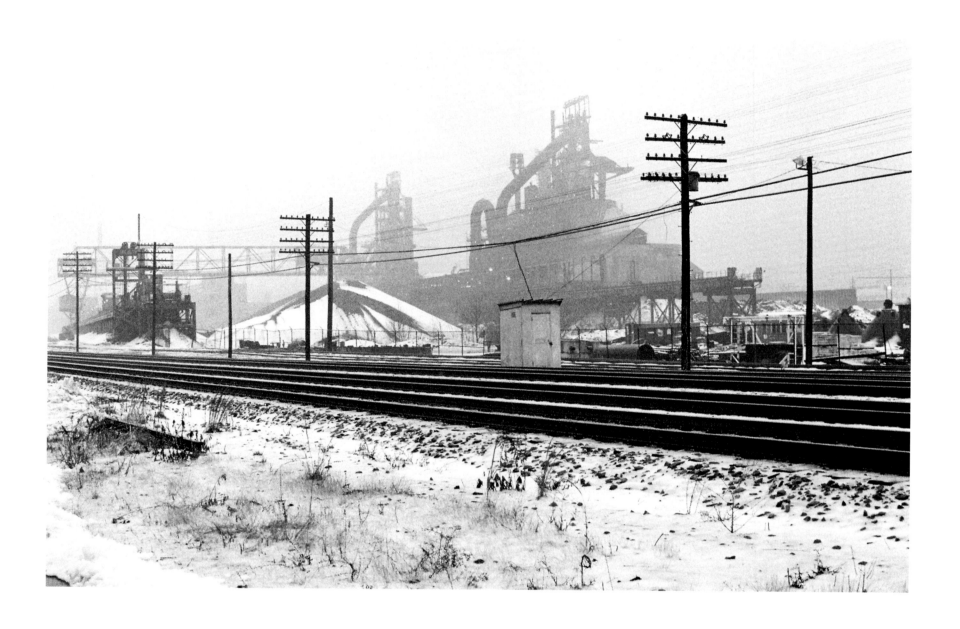

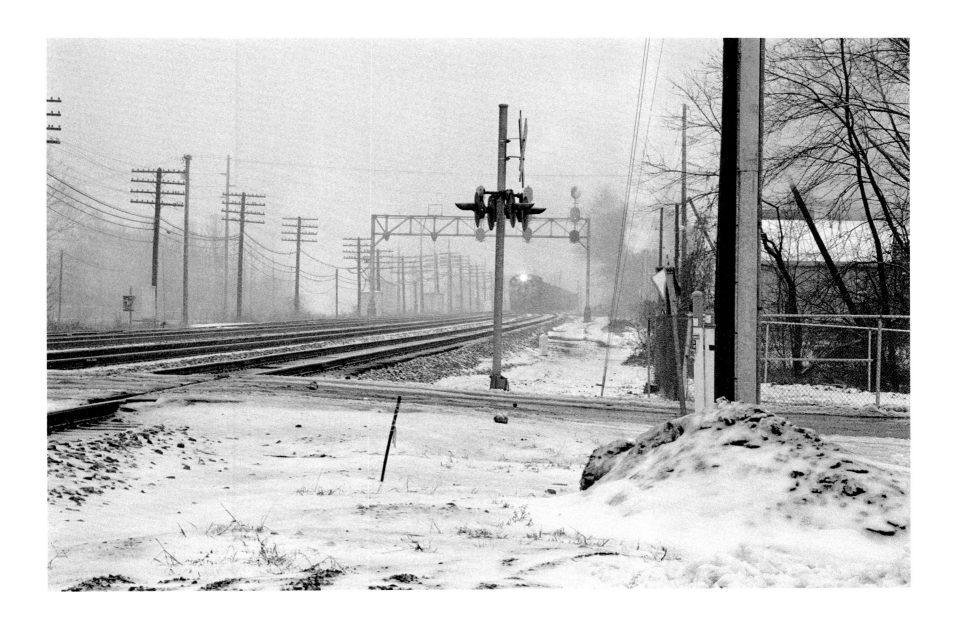

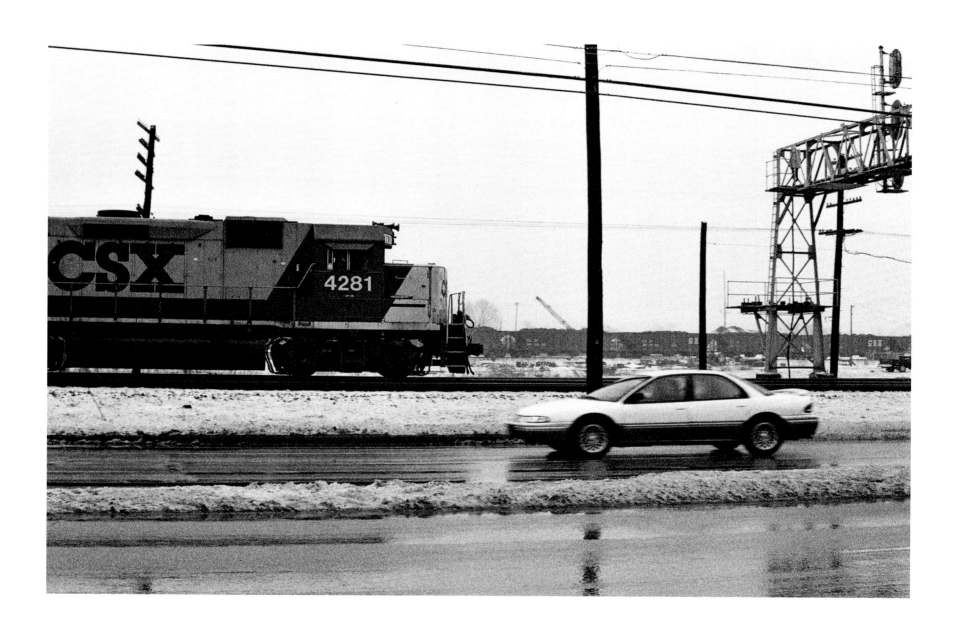

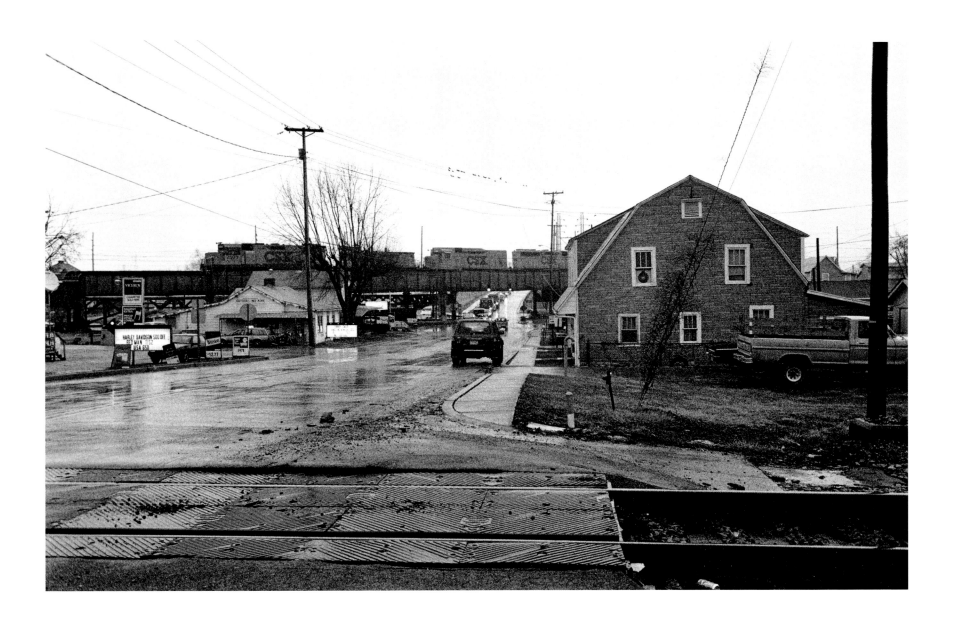

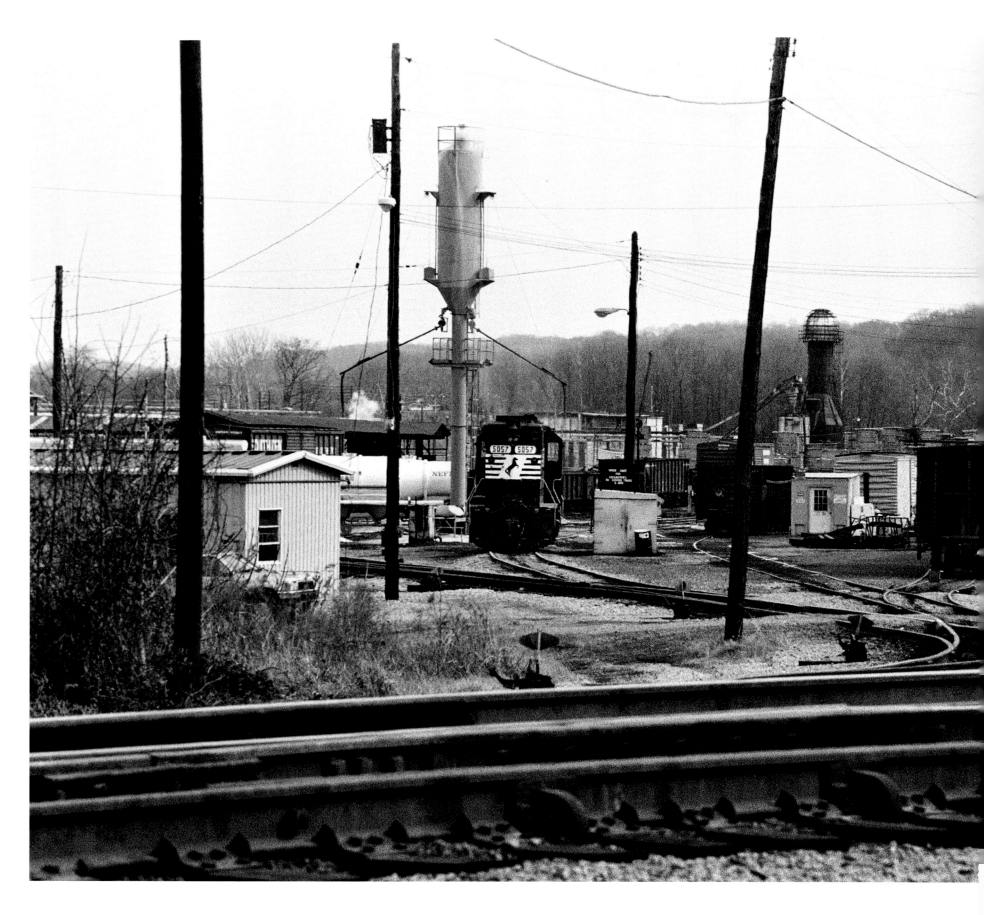

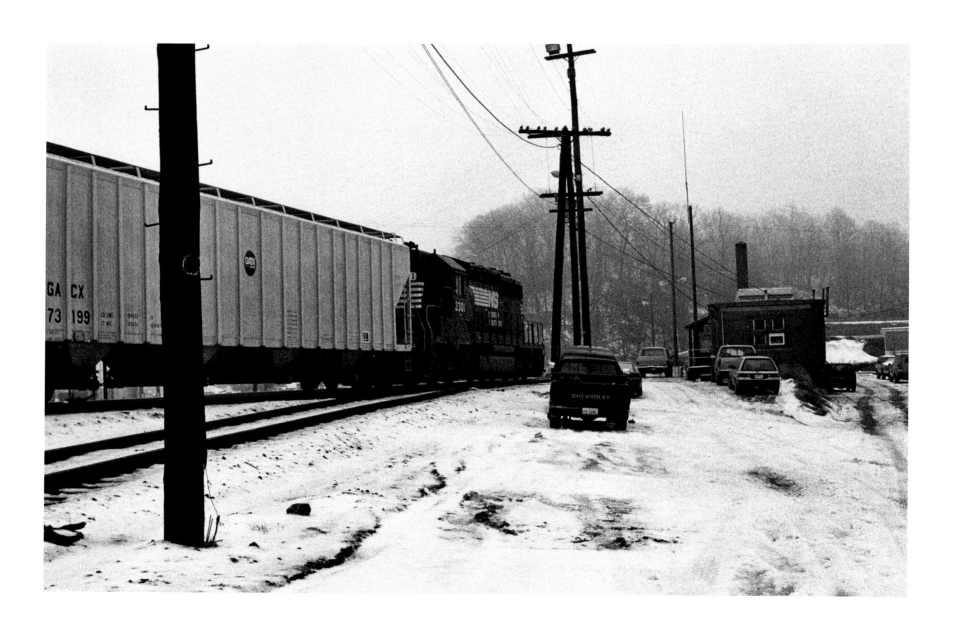

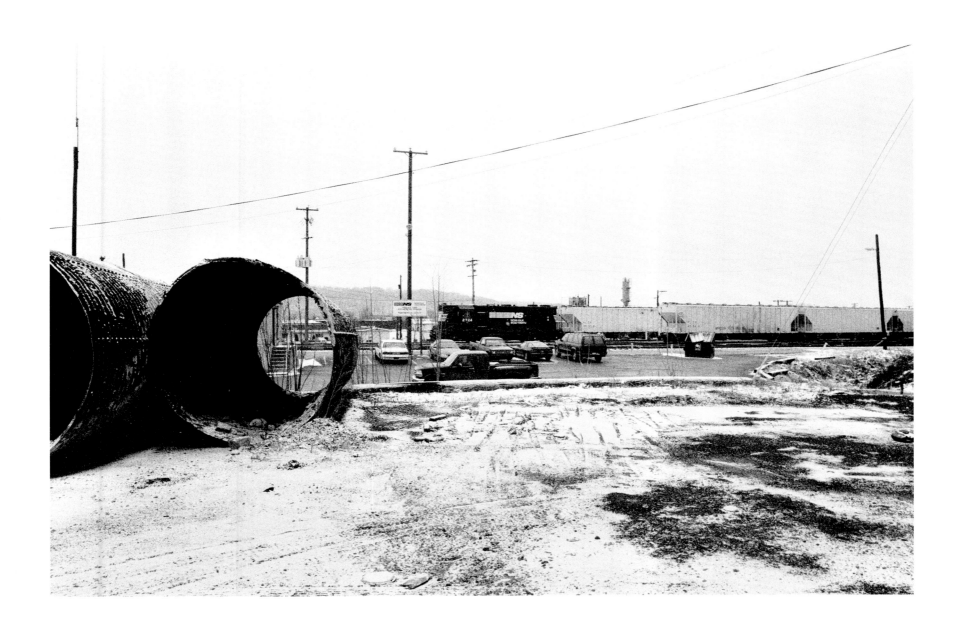

31

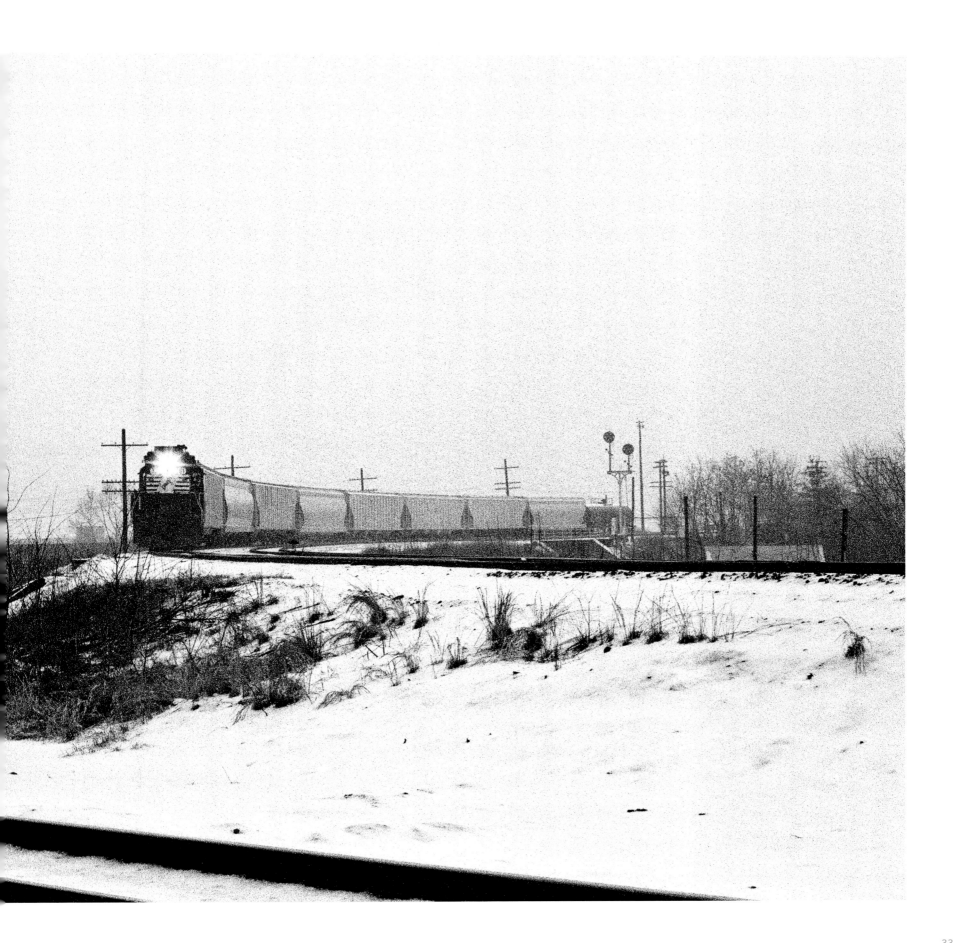

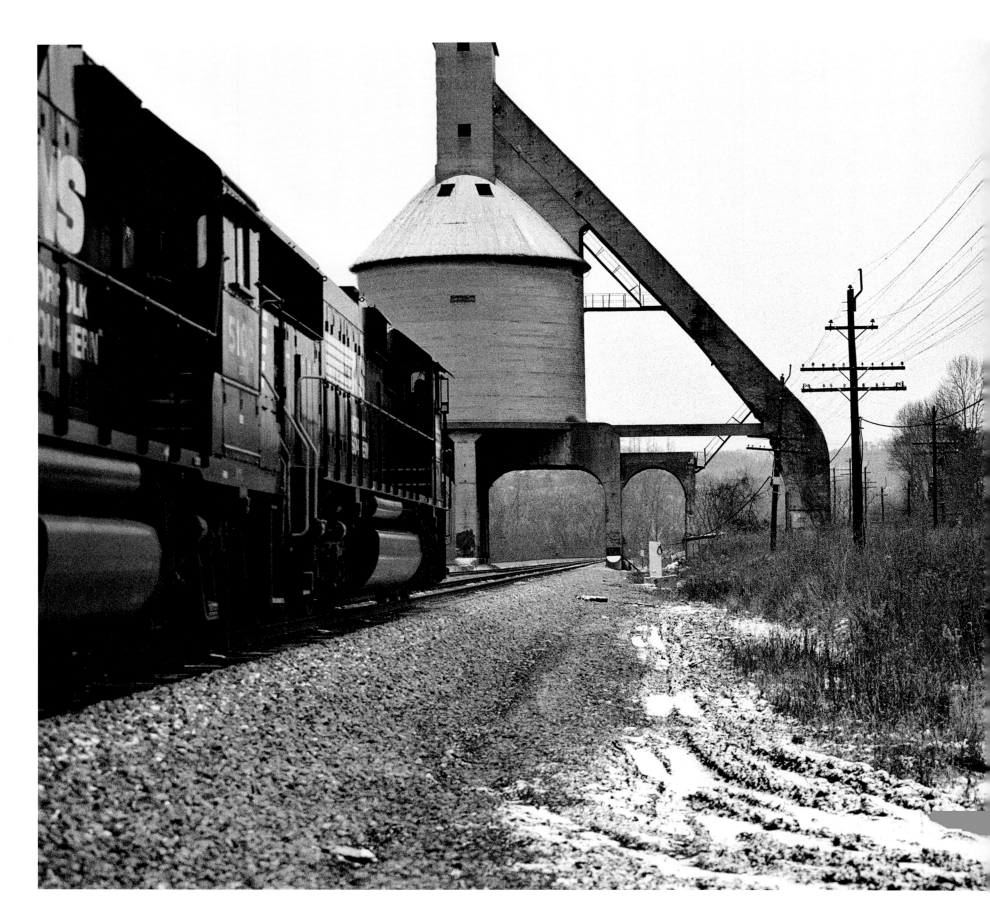

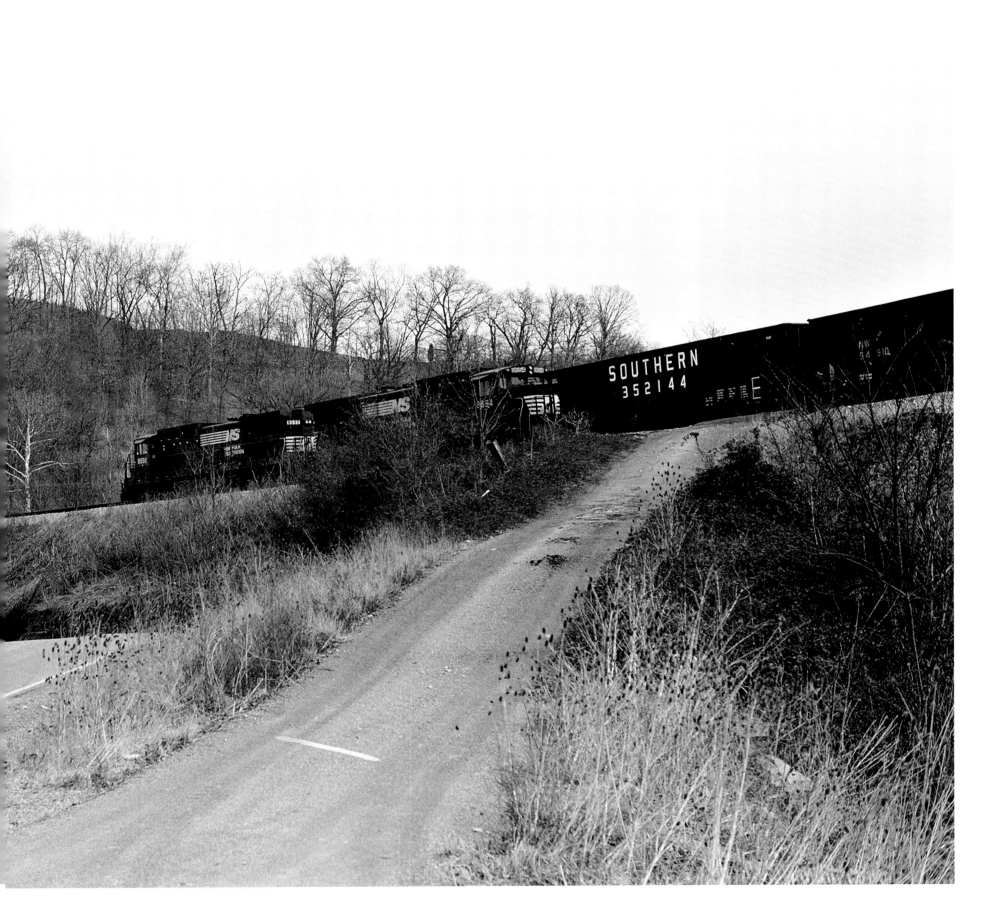

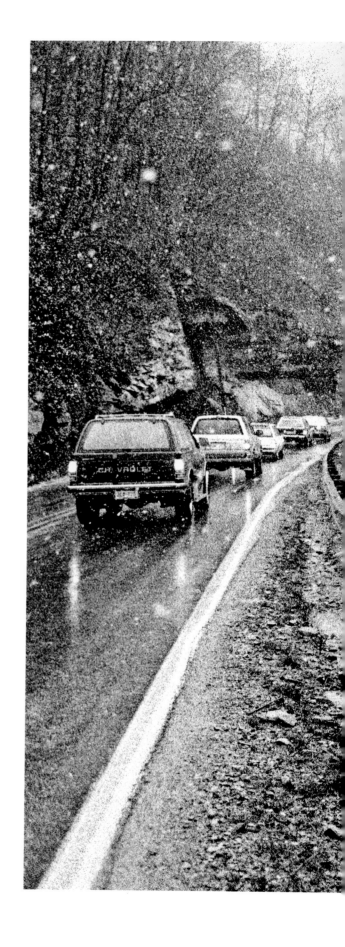

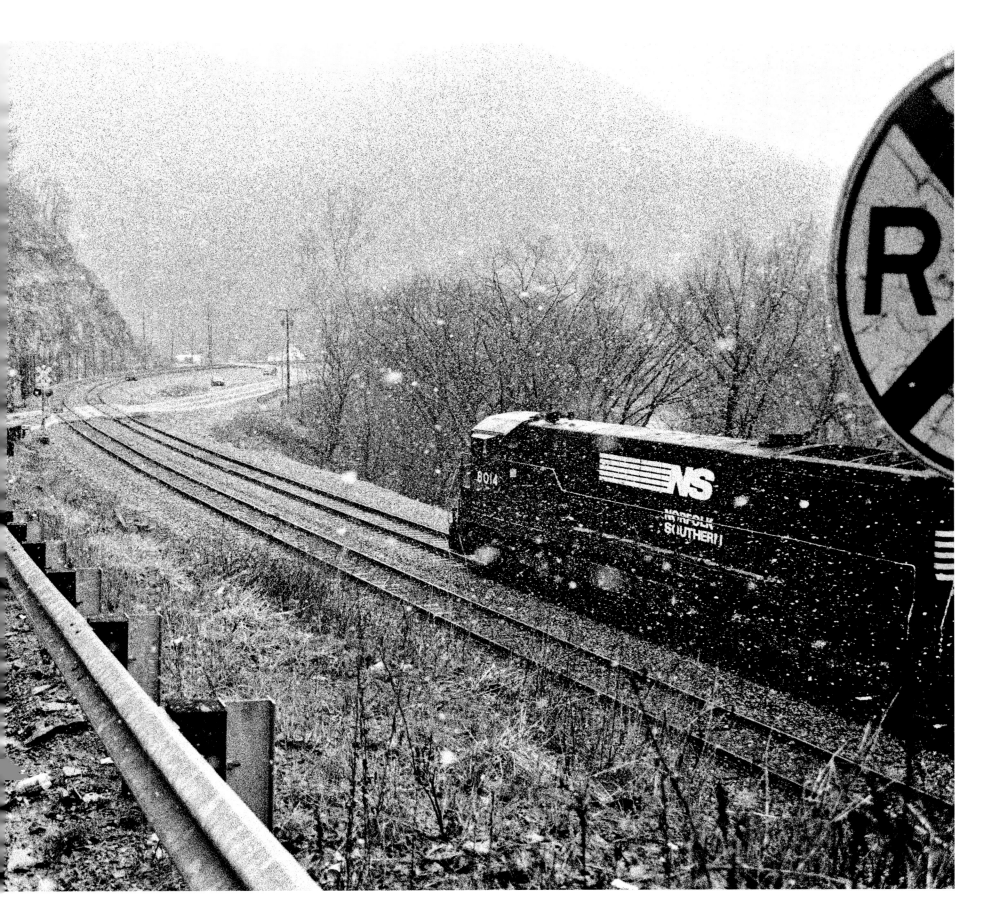

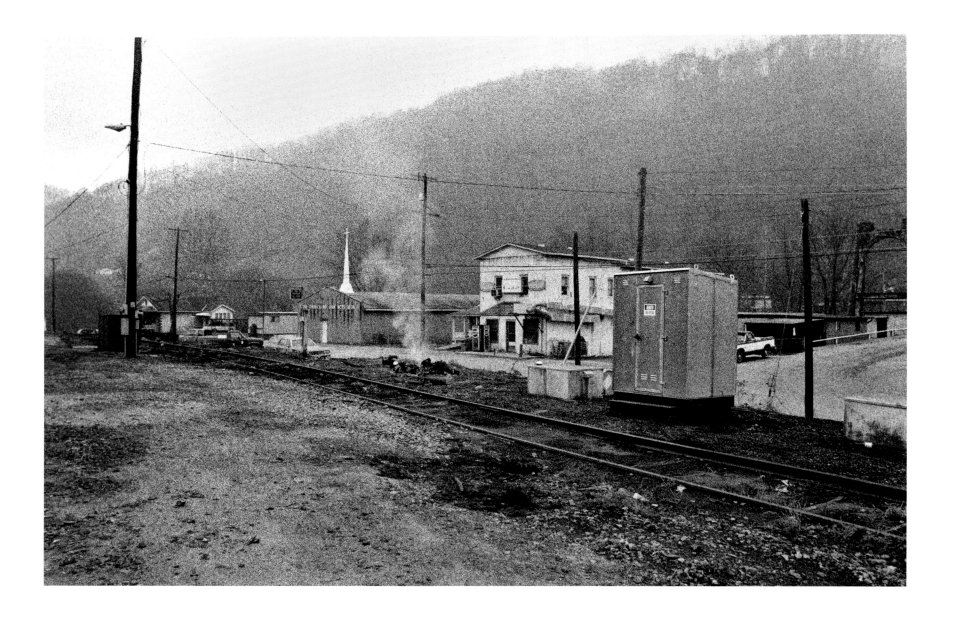

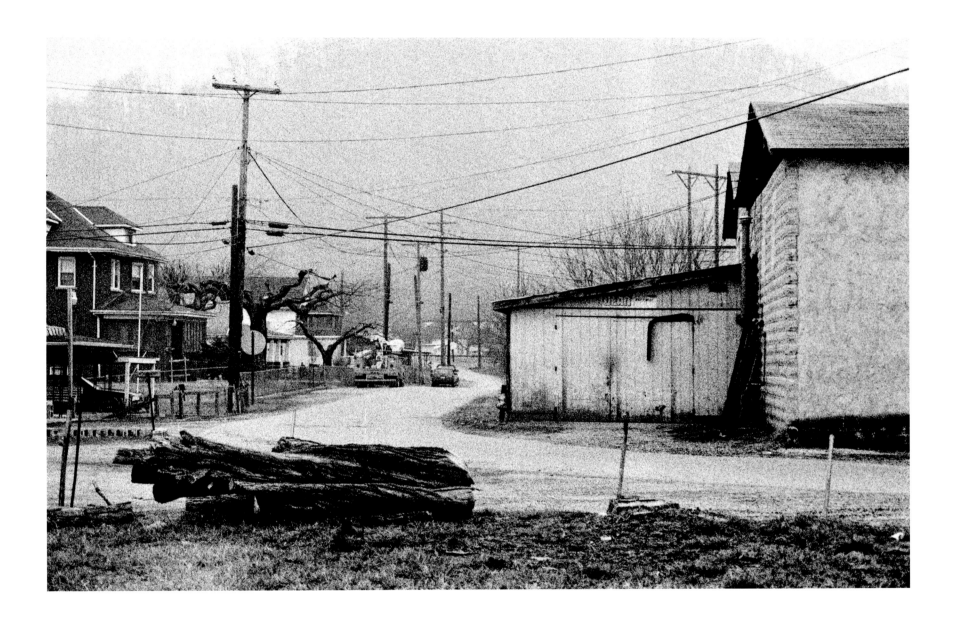

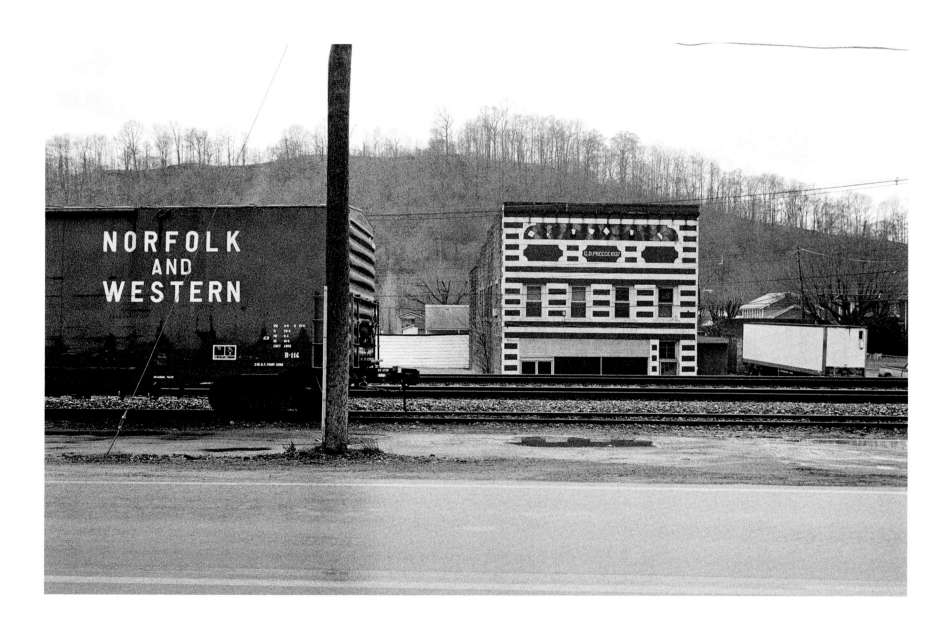

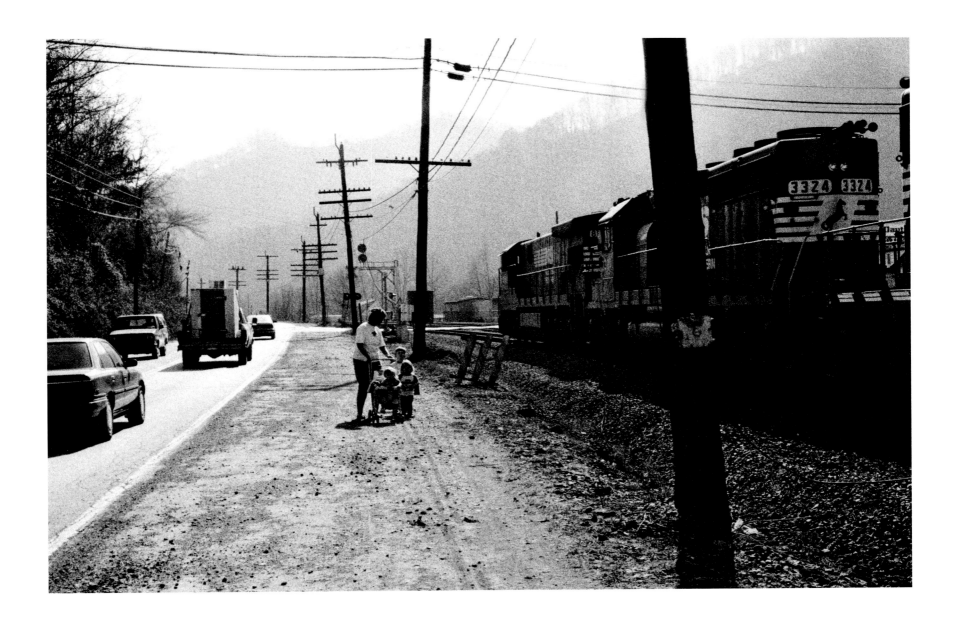

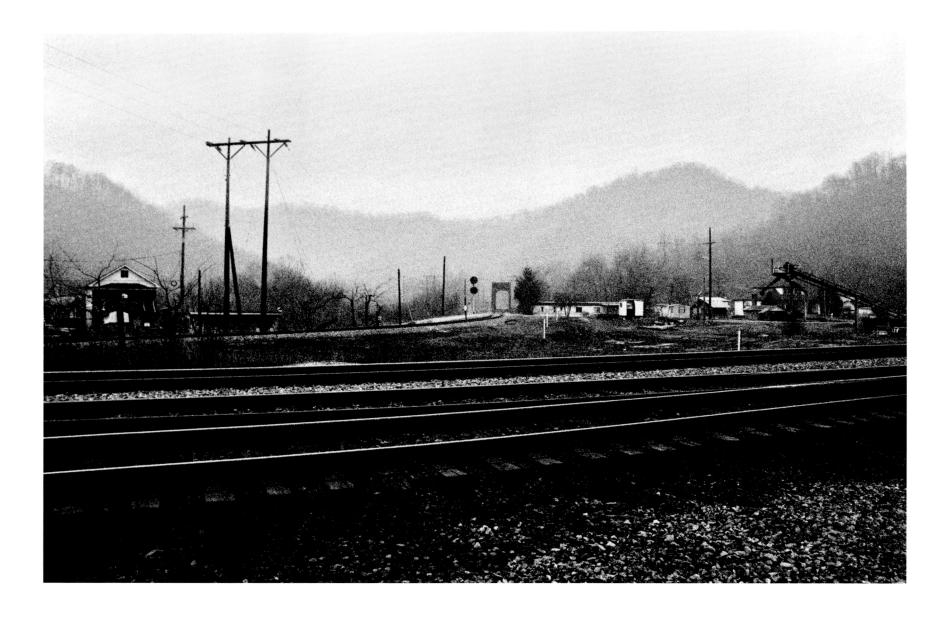

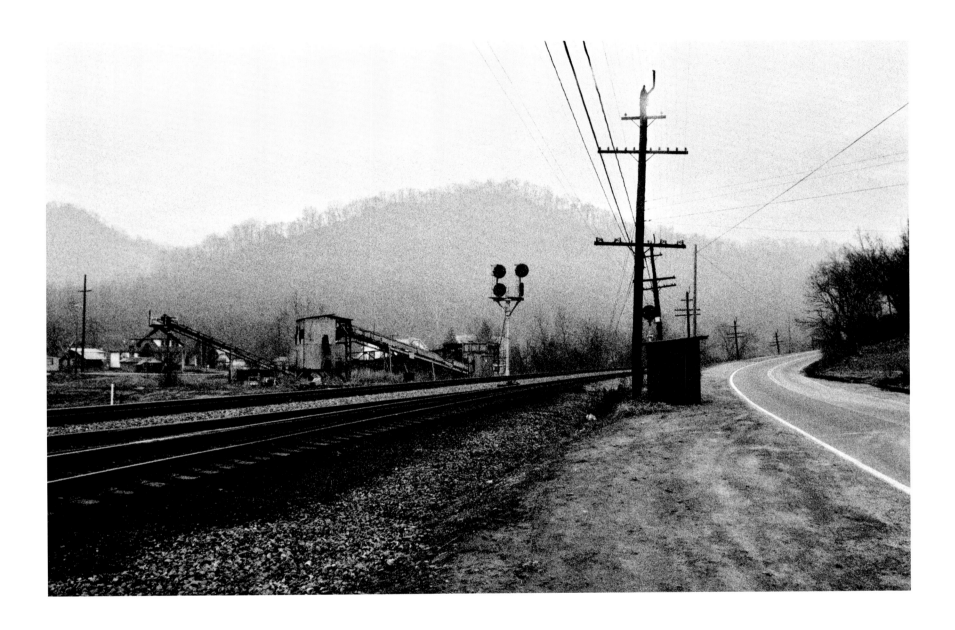

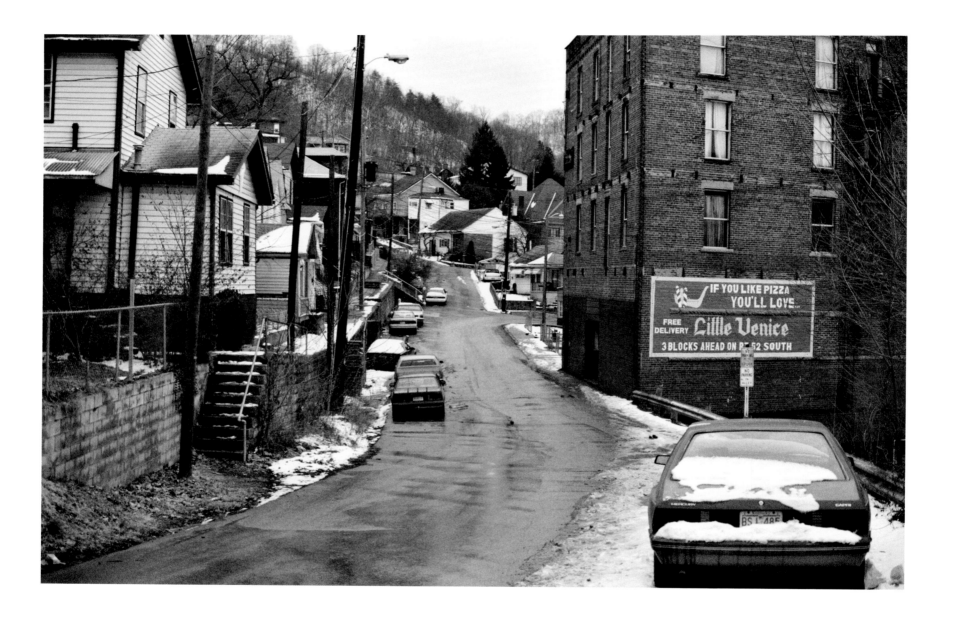

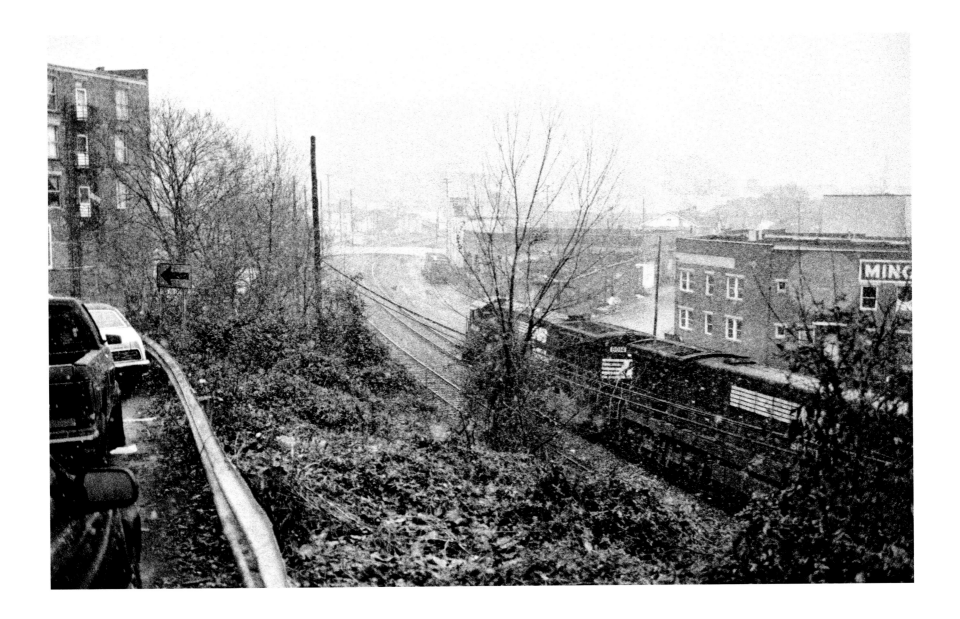

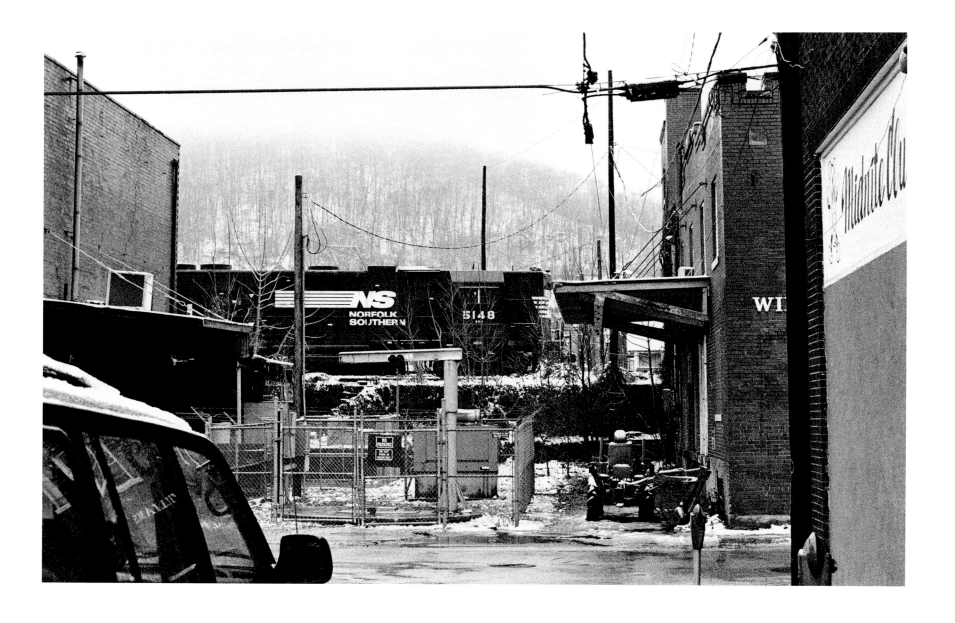

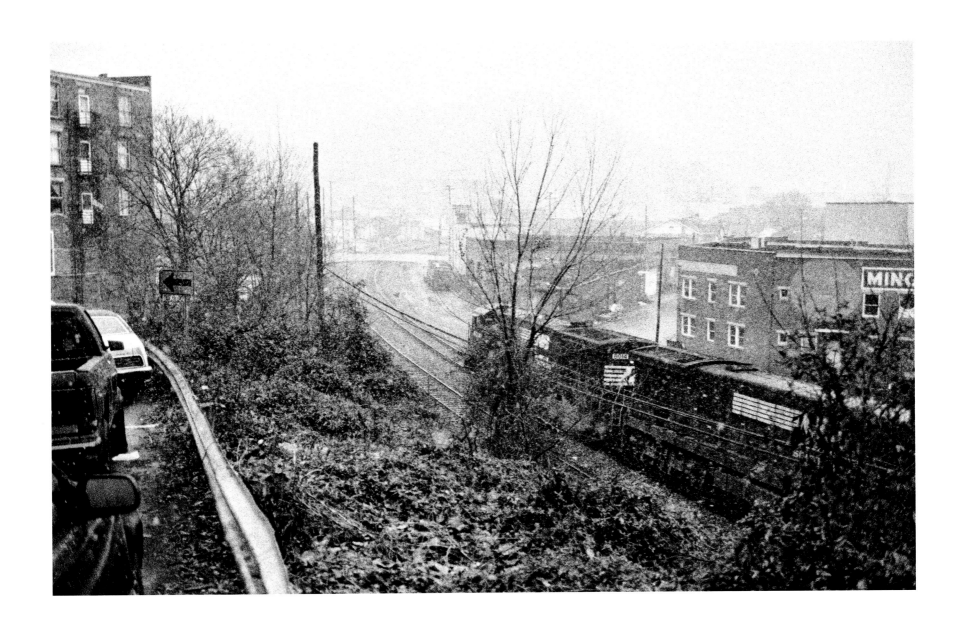

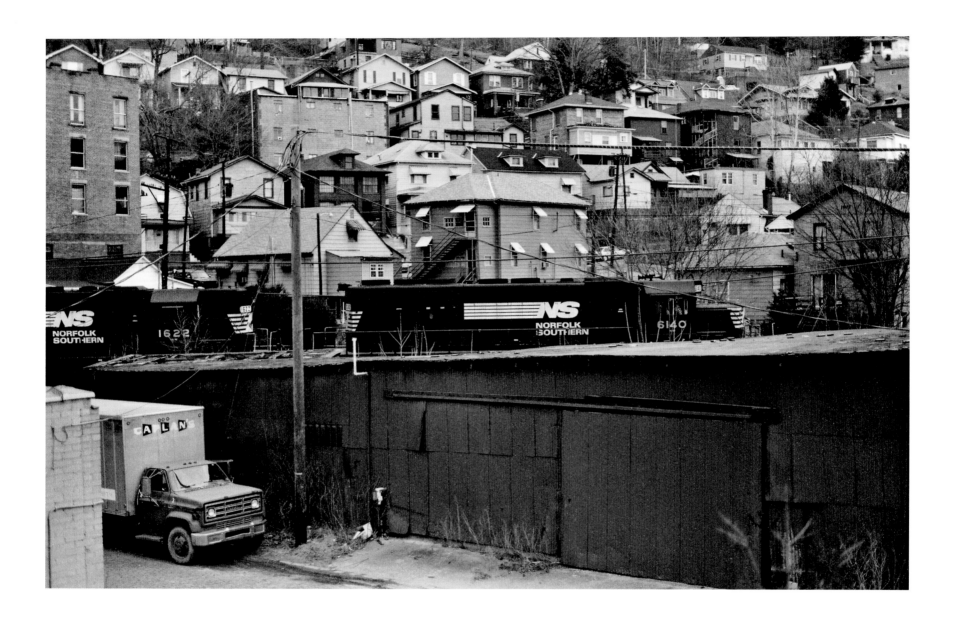

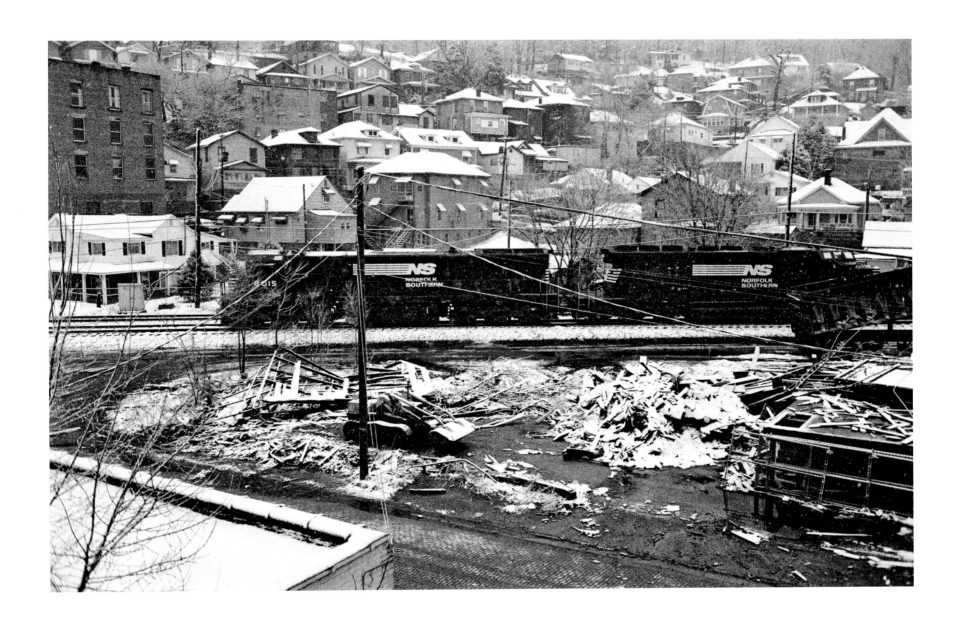

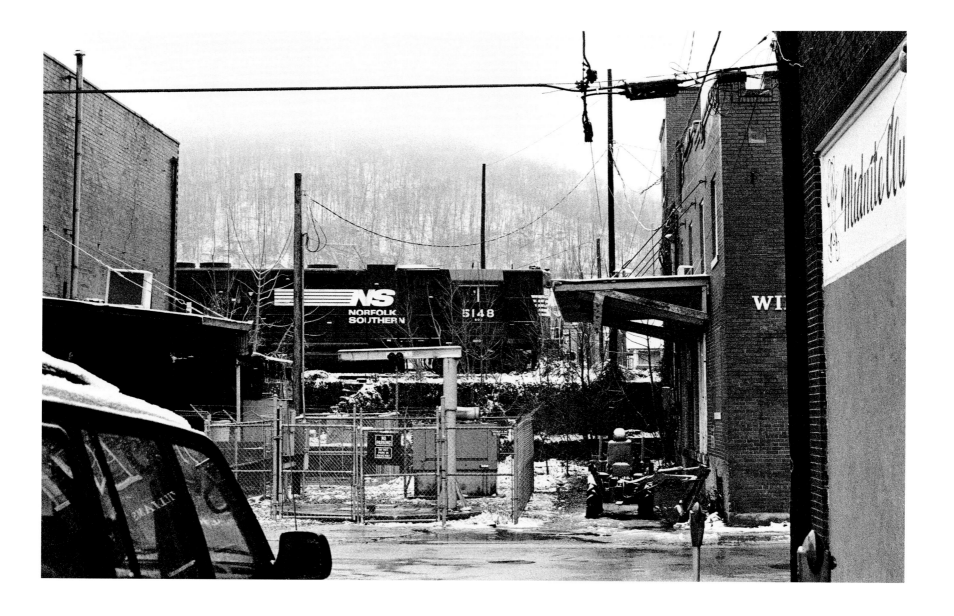

50

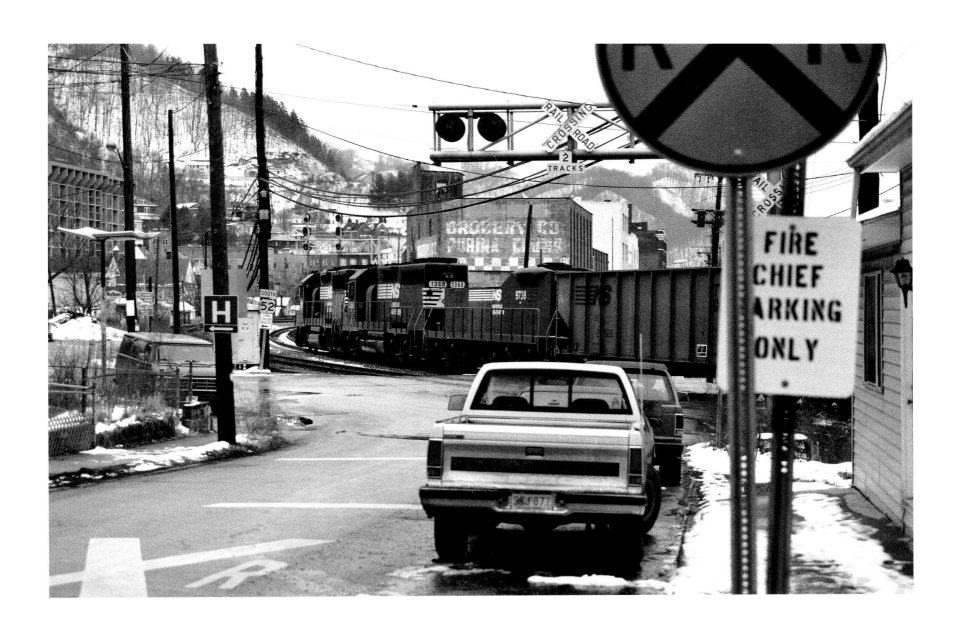

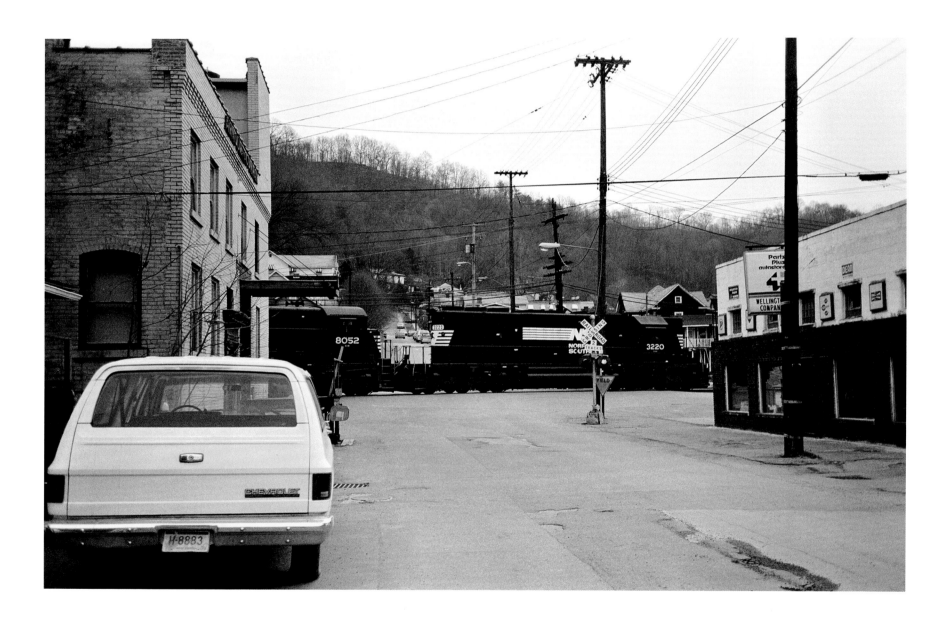

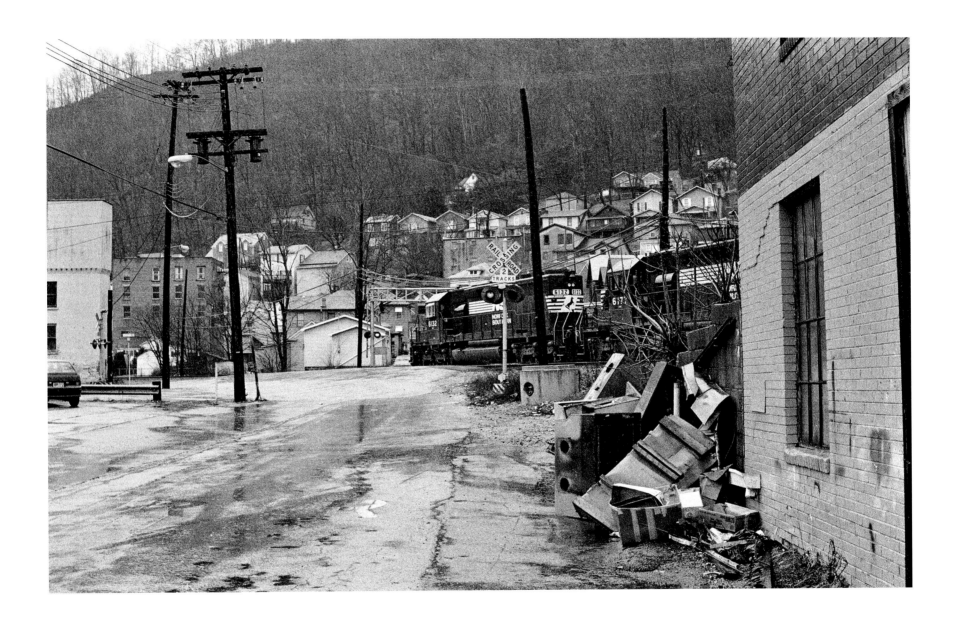

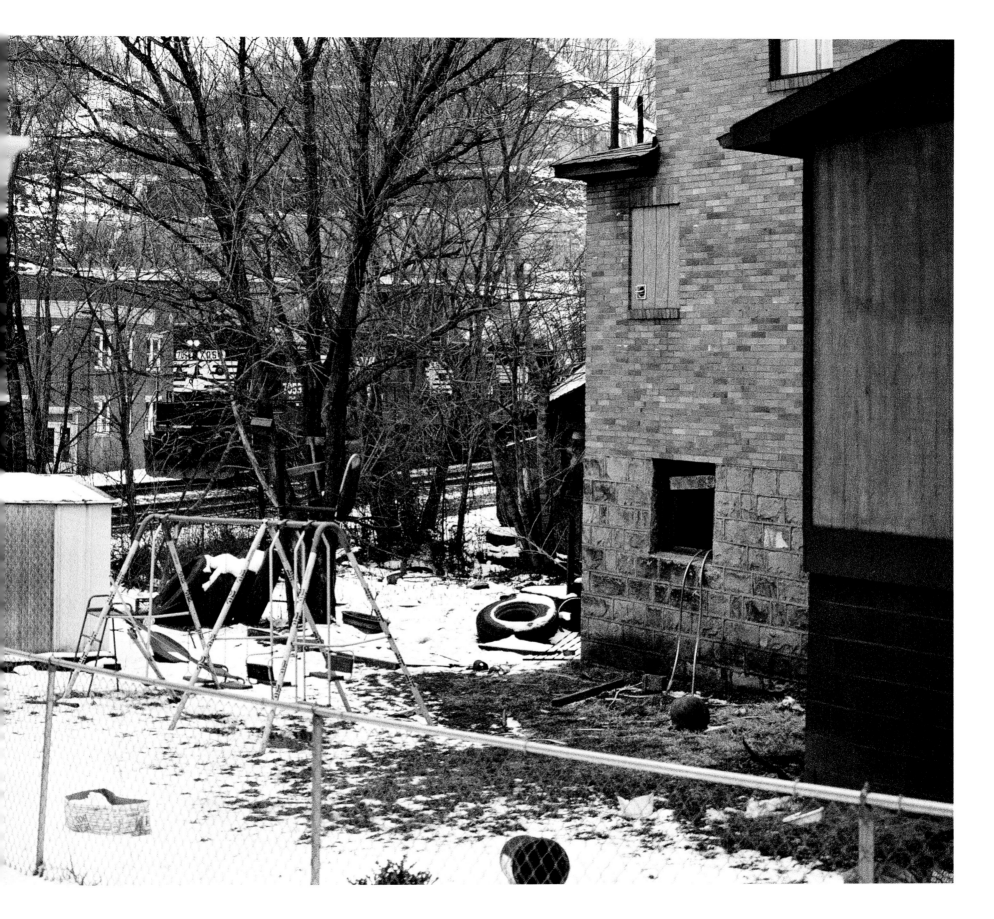

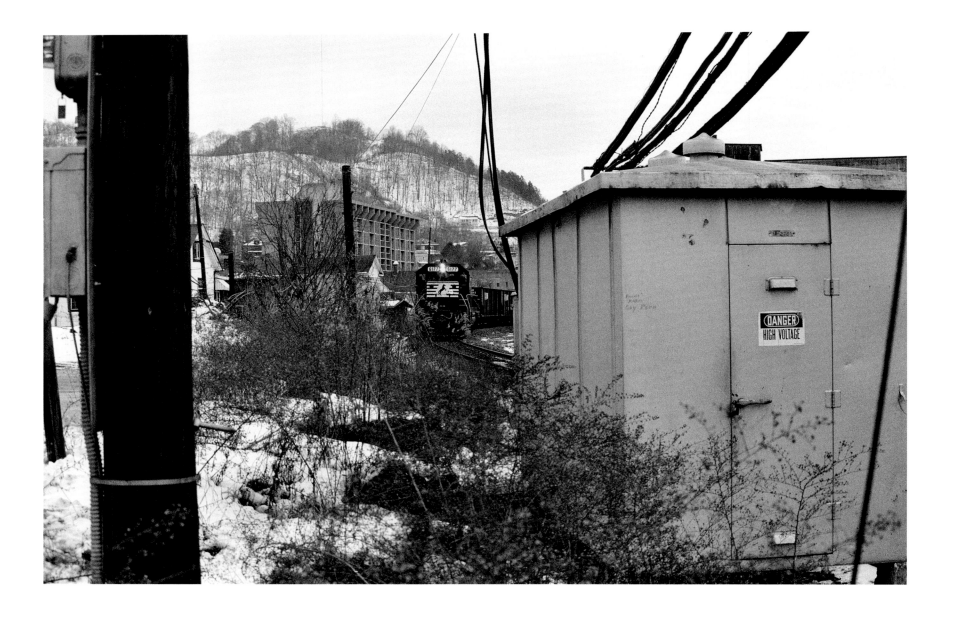

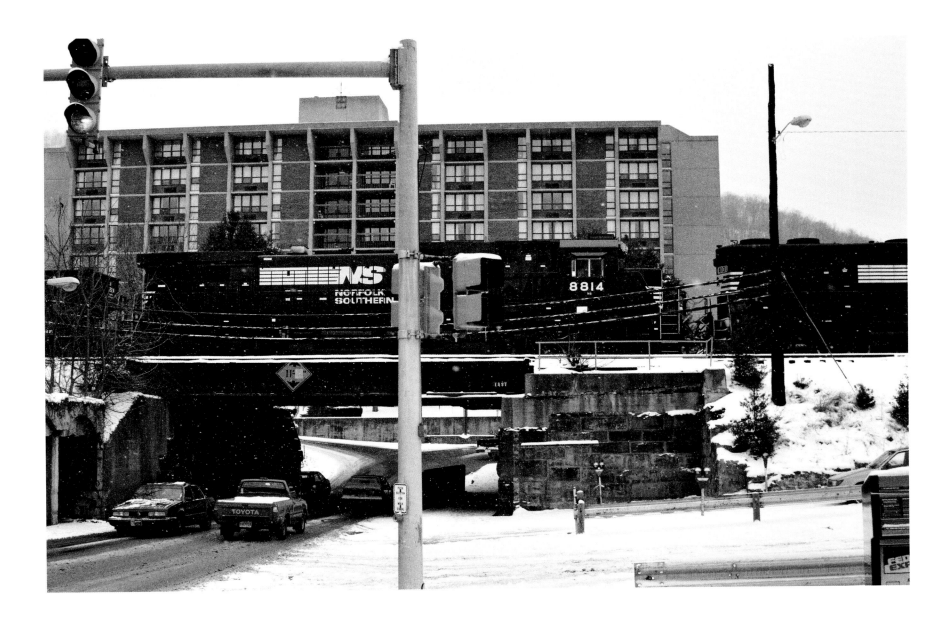

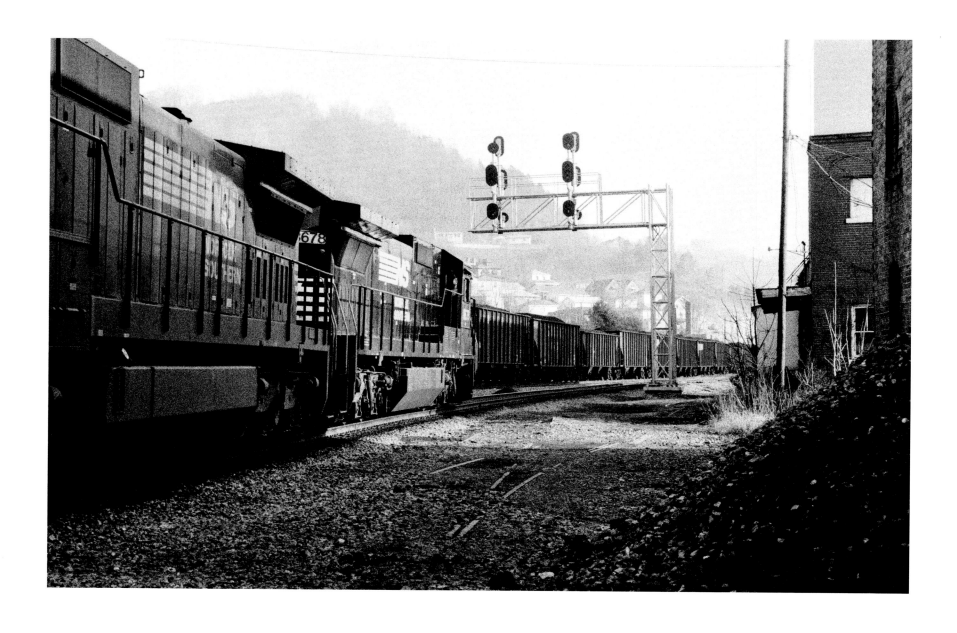

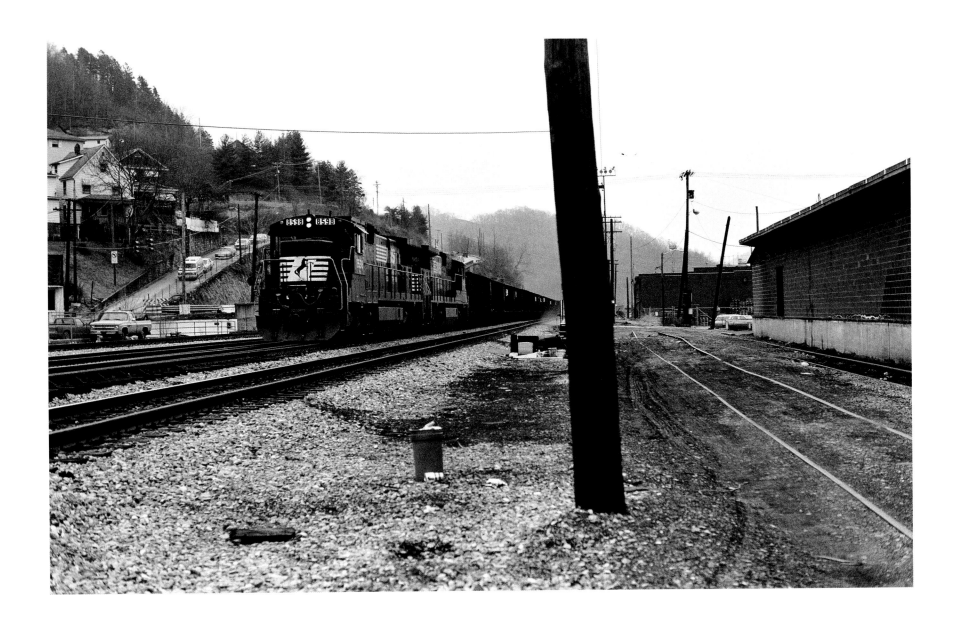

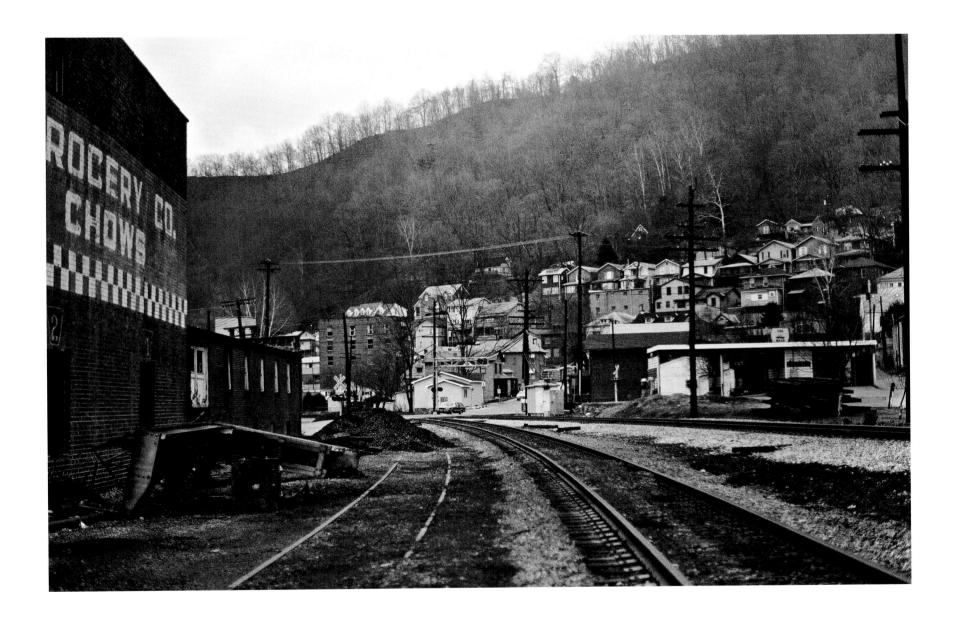

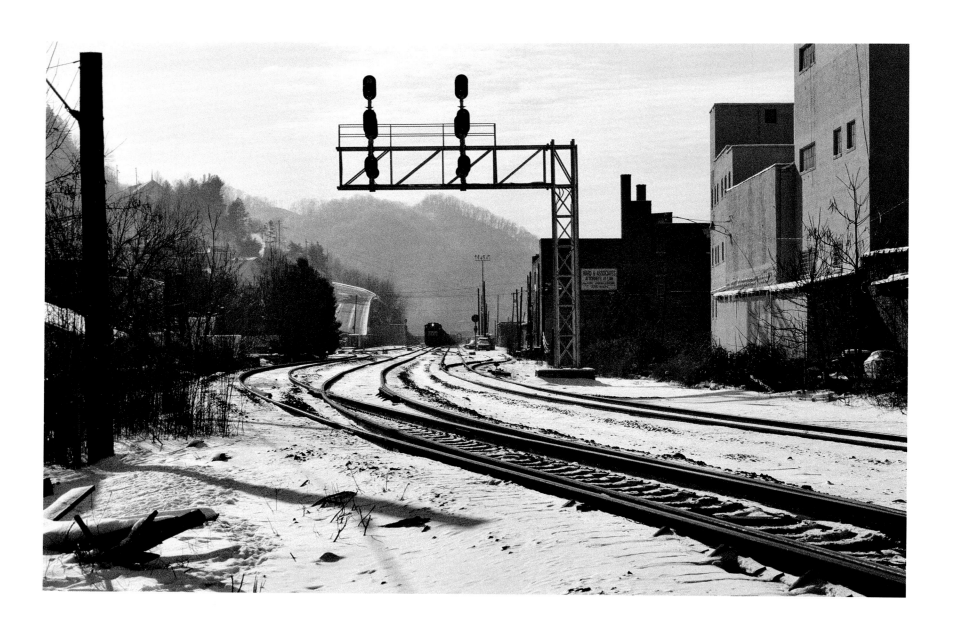

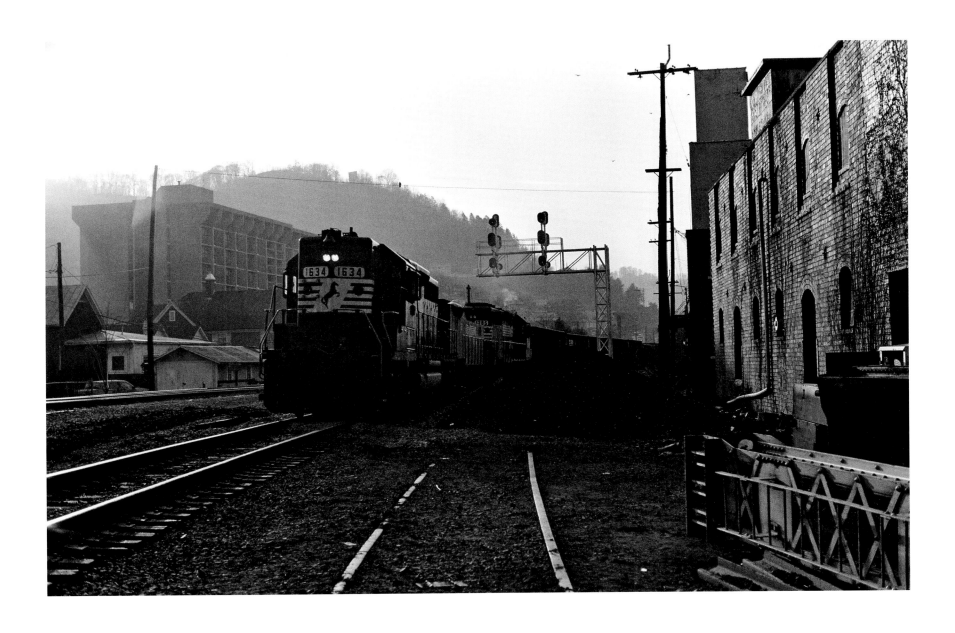

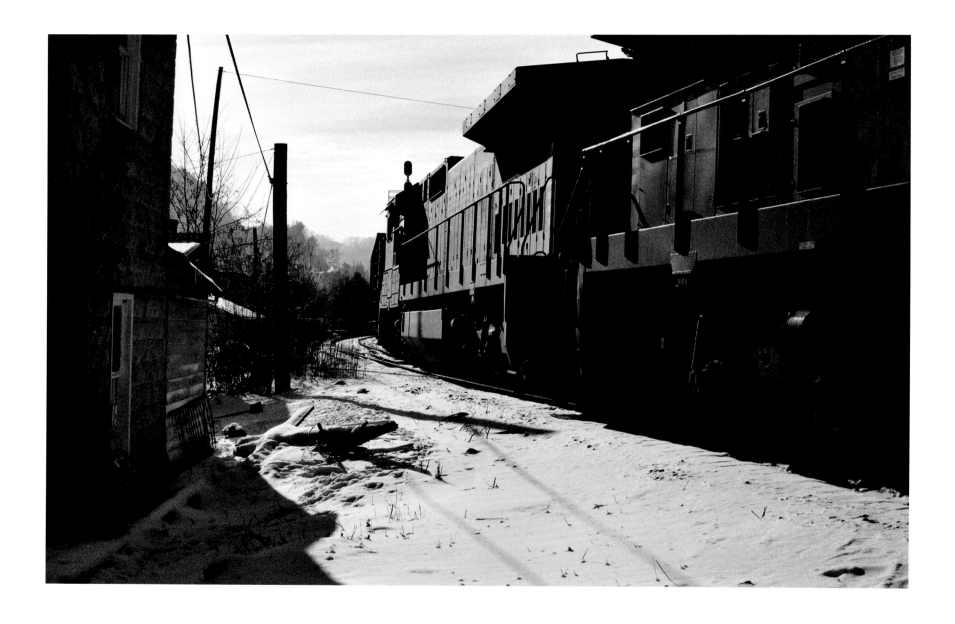

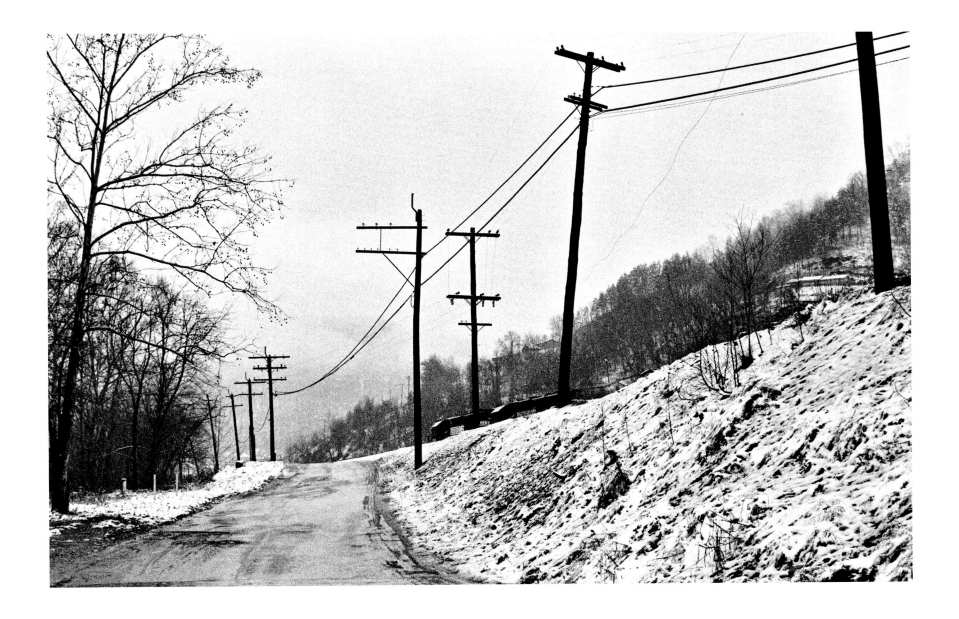

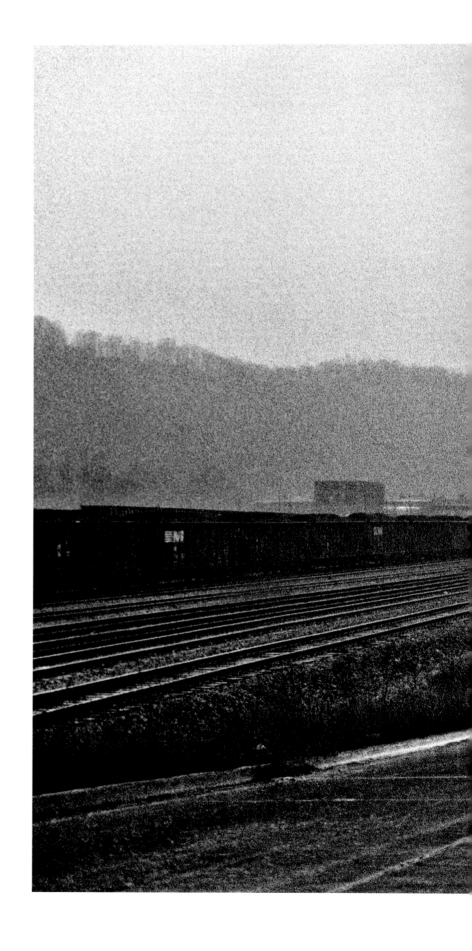

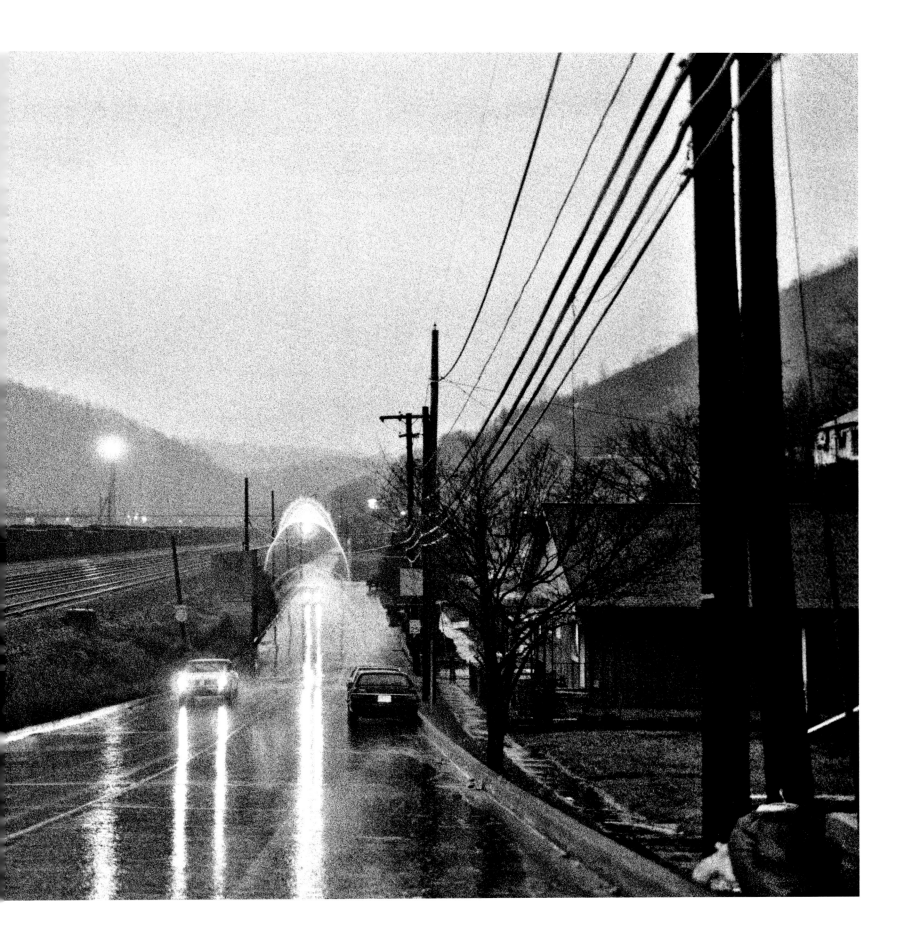

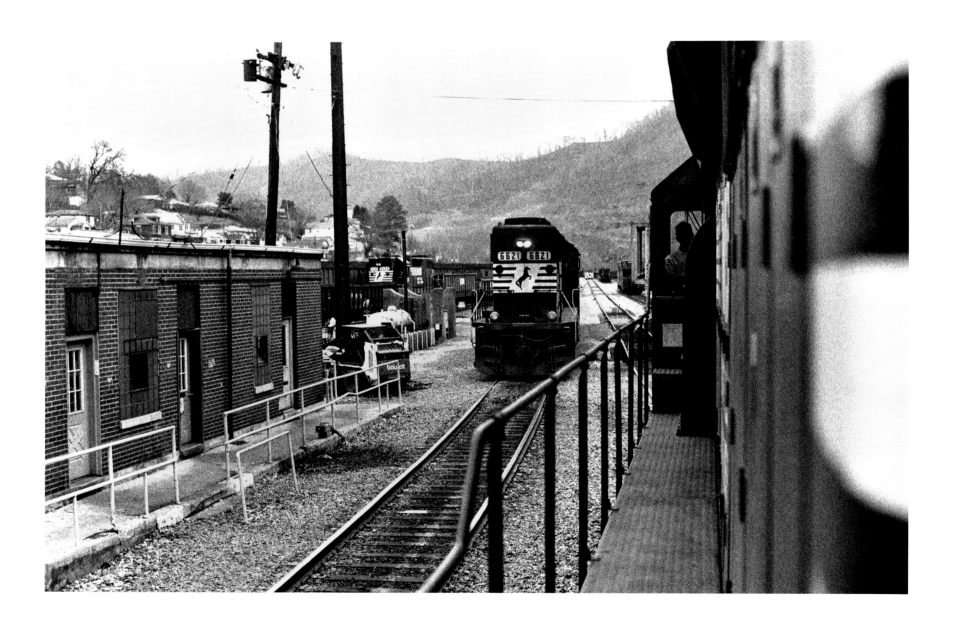

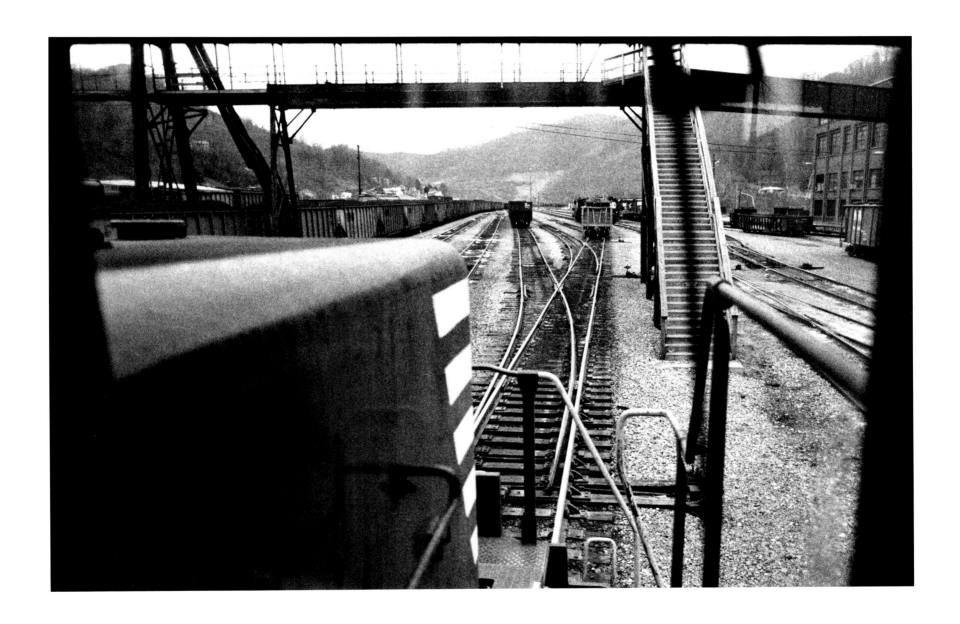

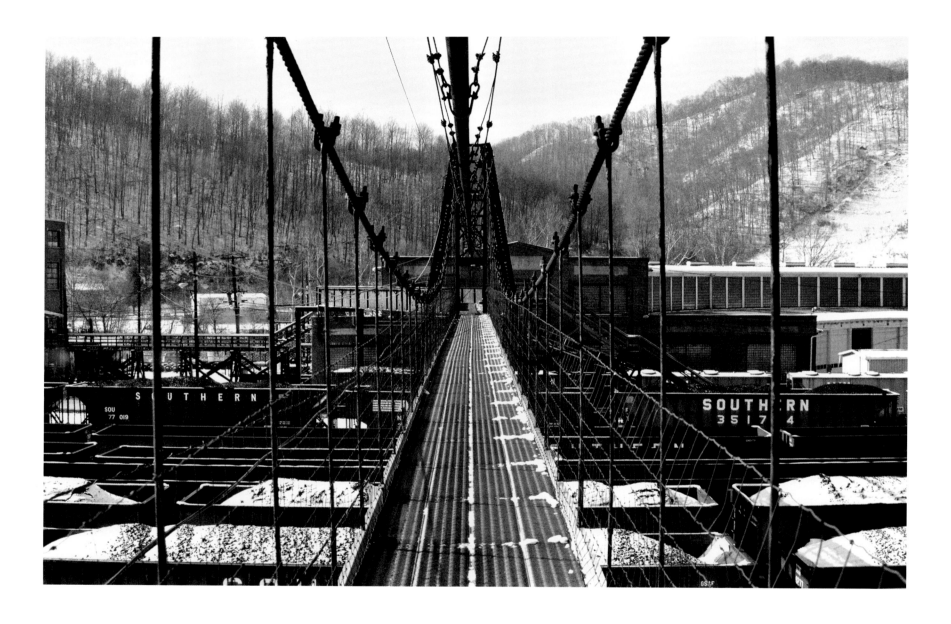

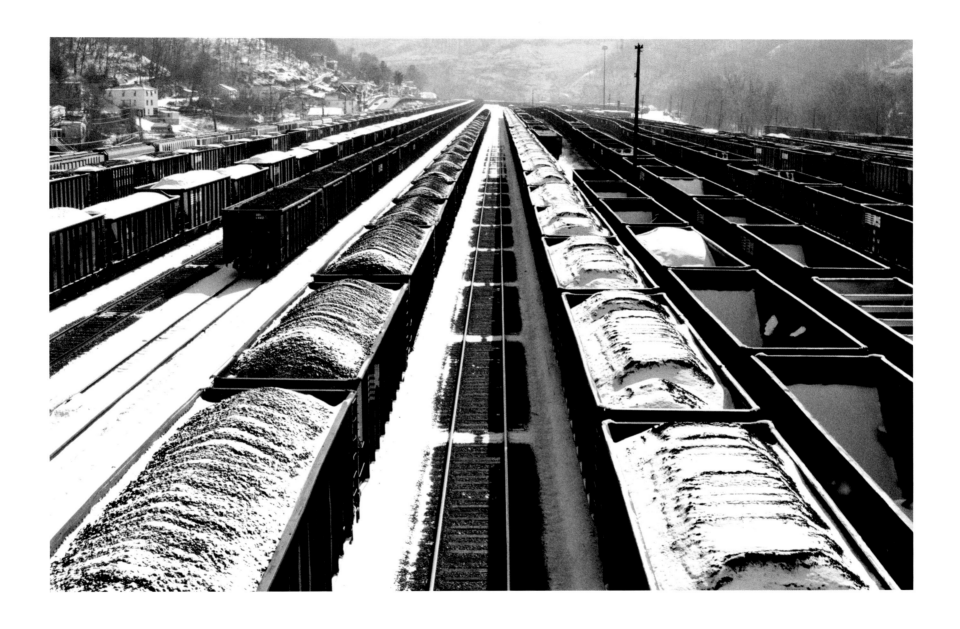

71

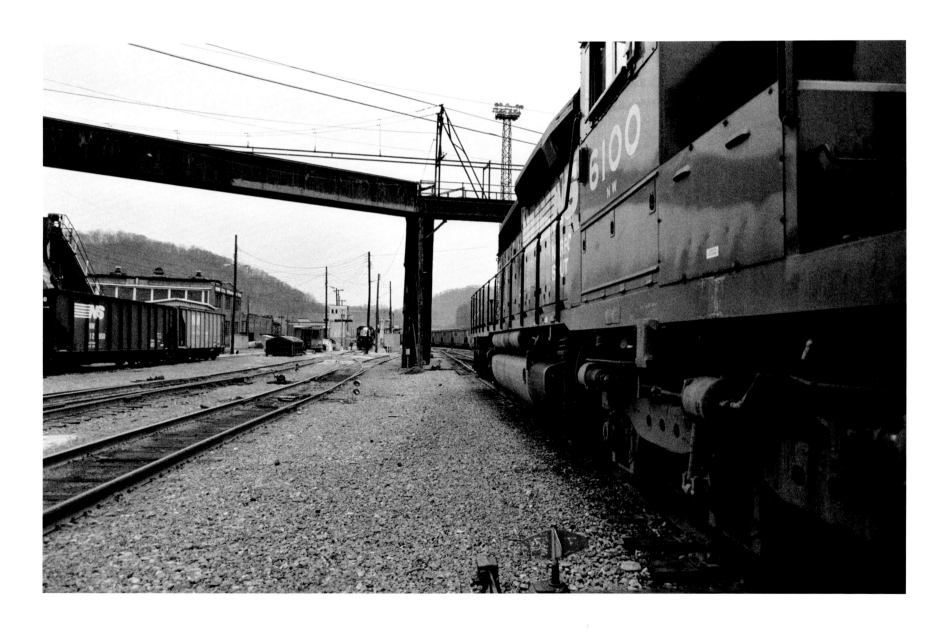

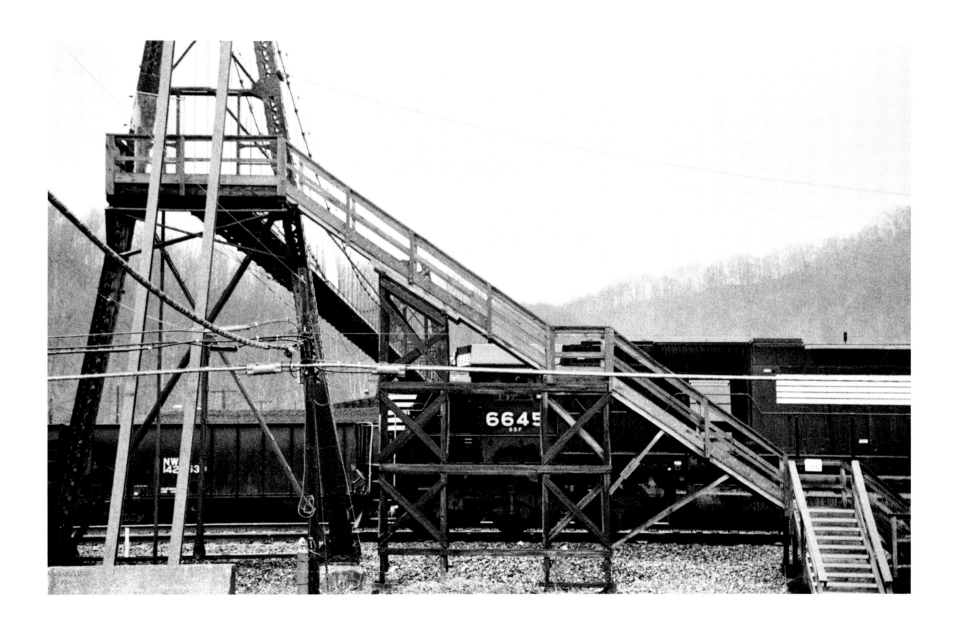

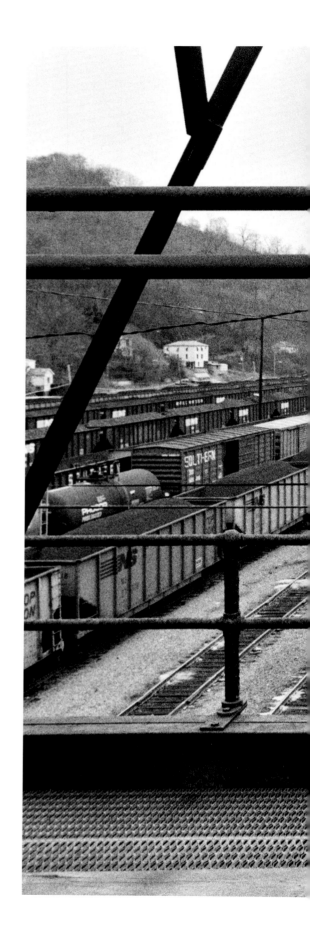

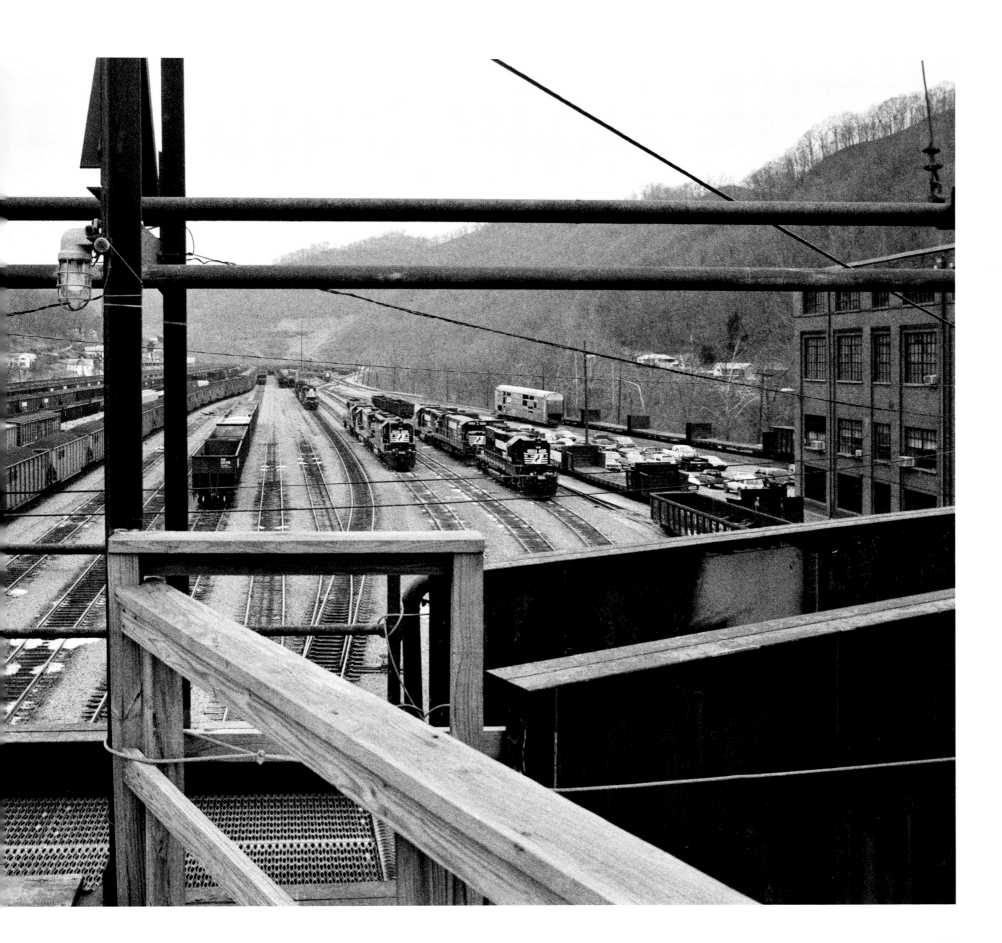

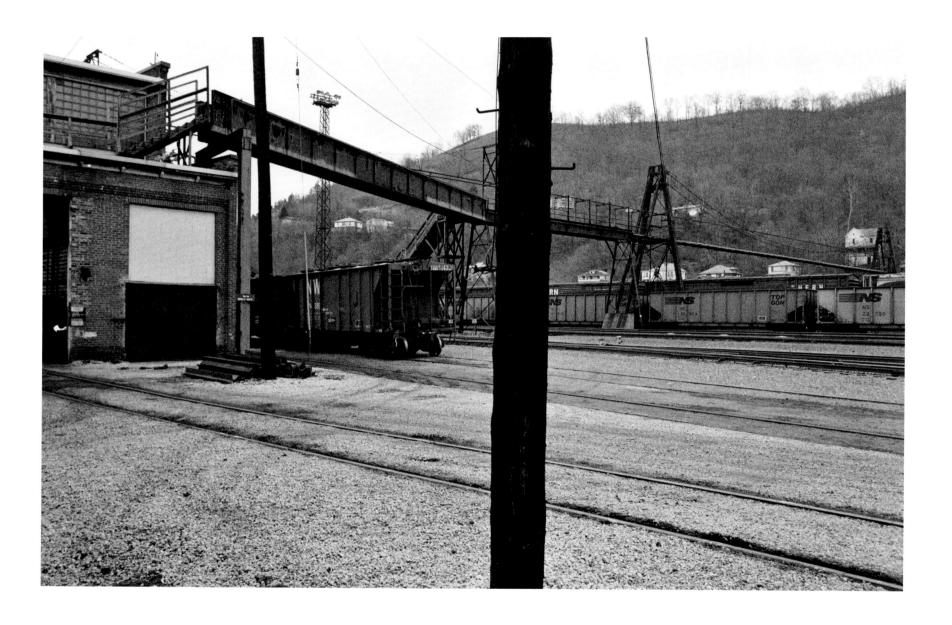

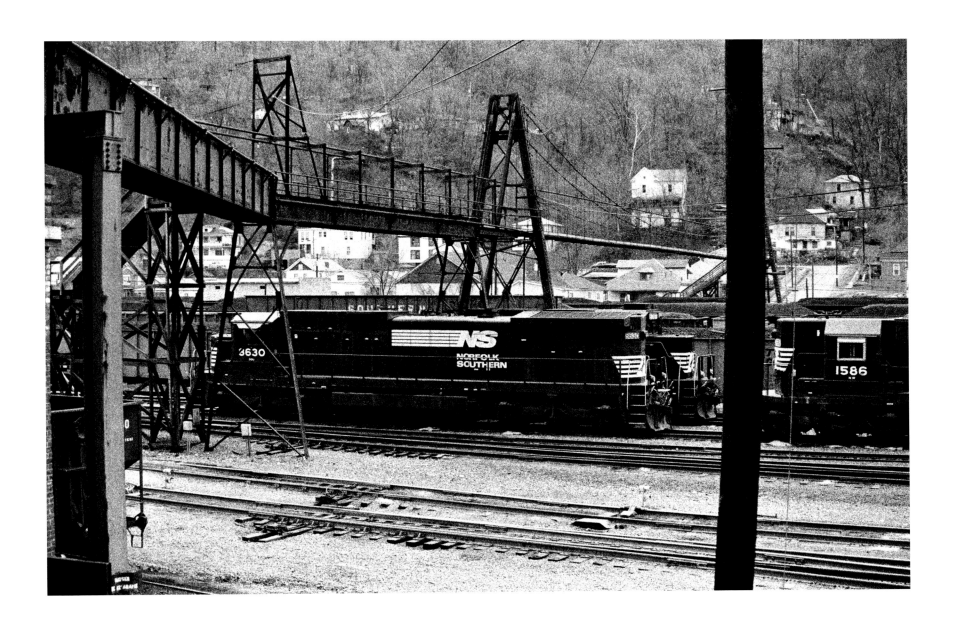

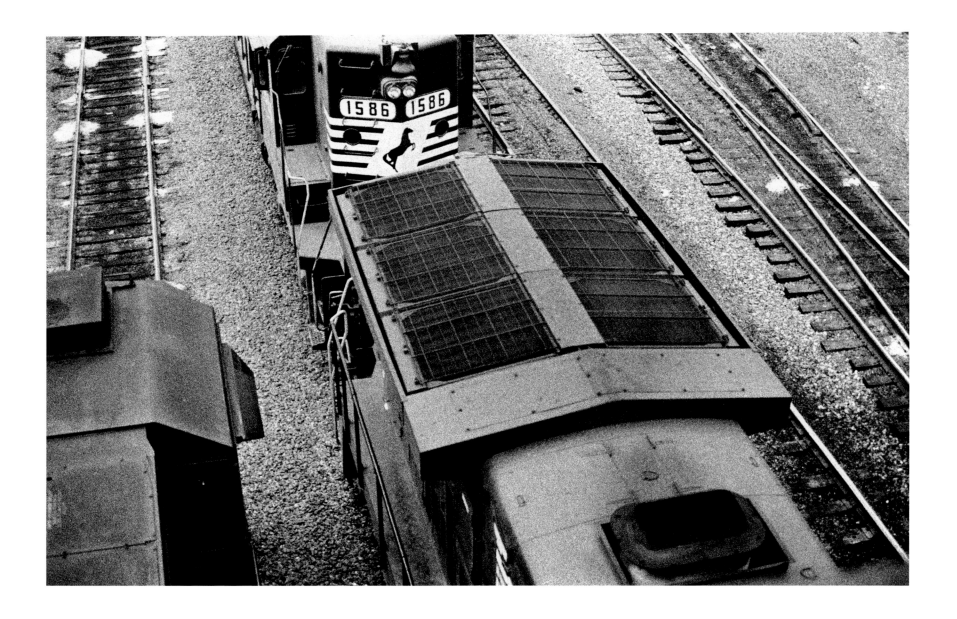

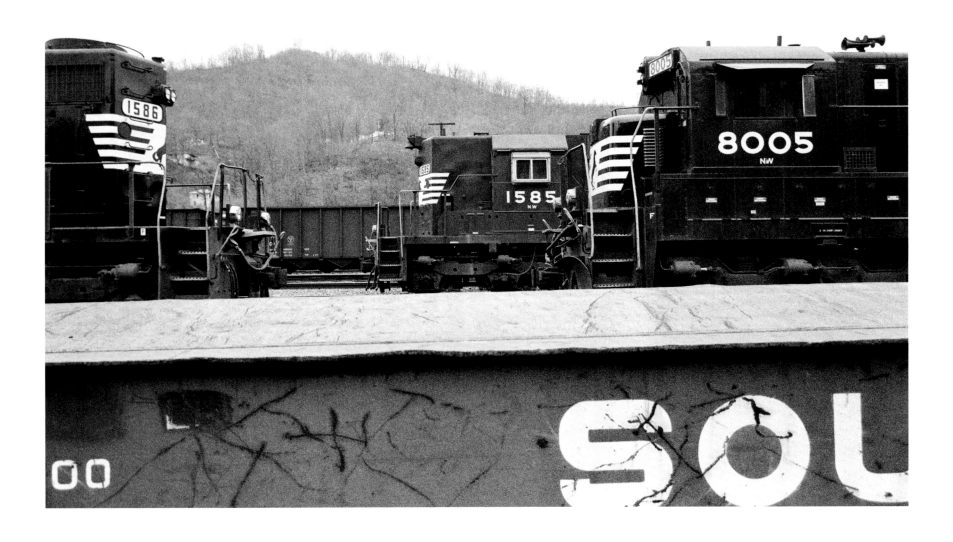

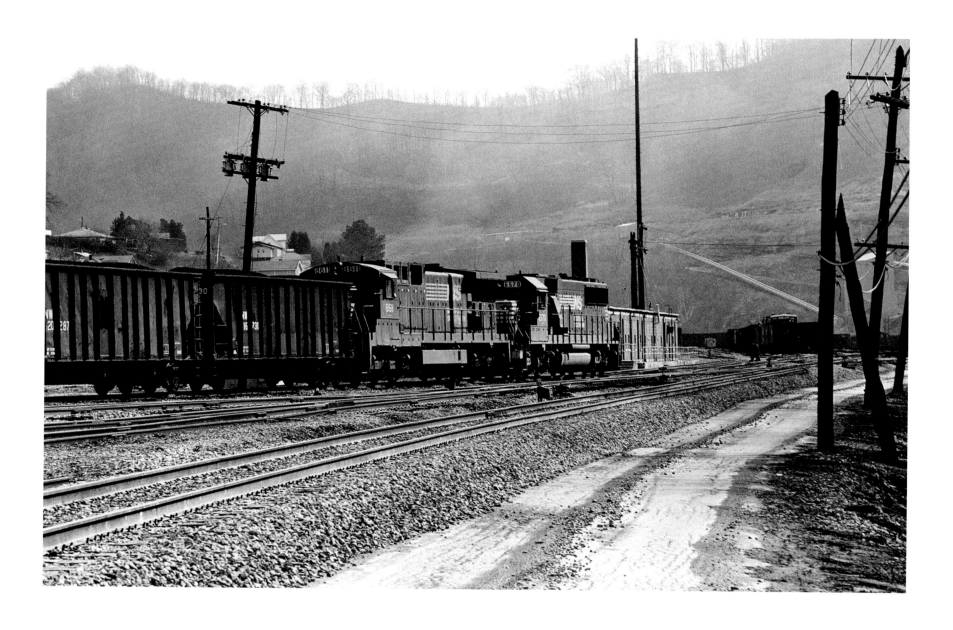

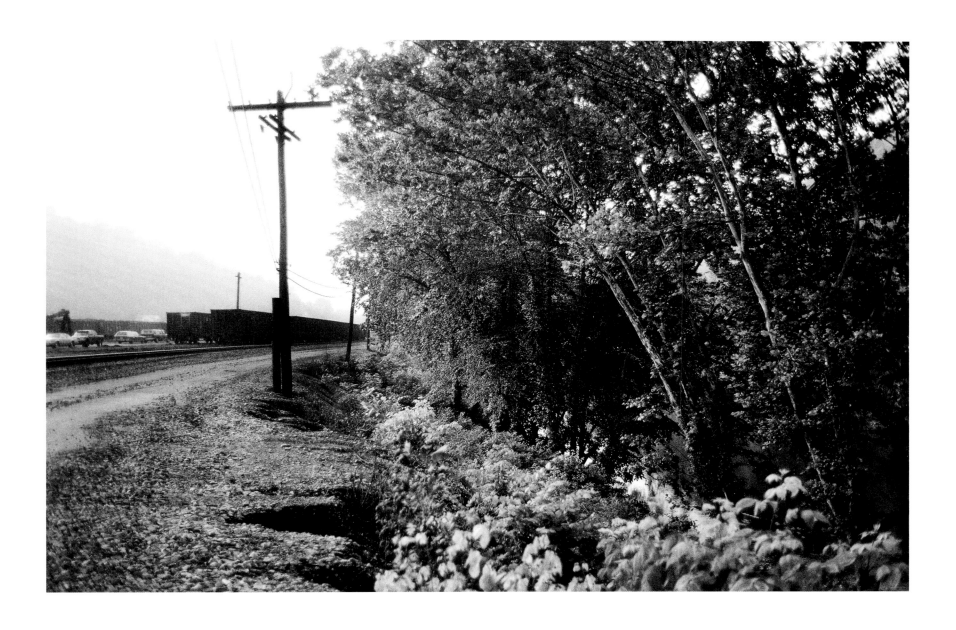

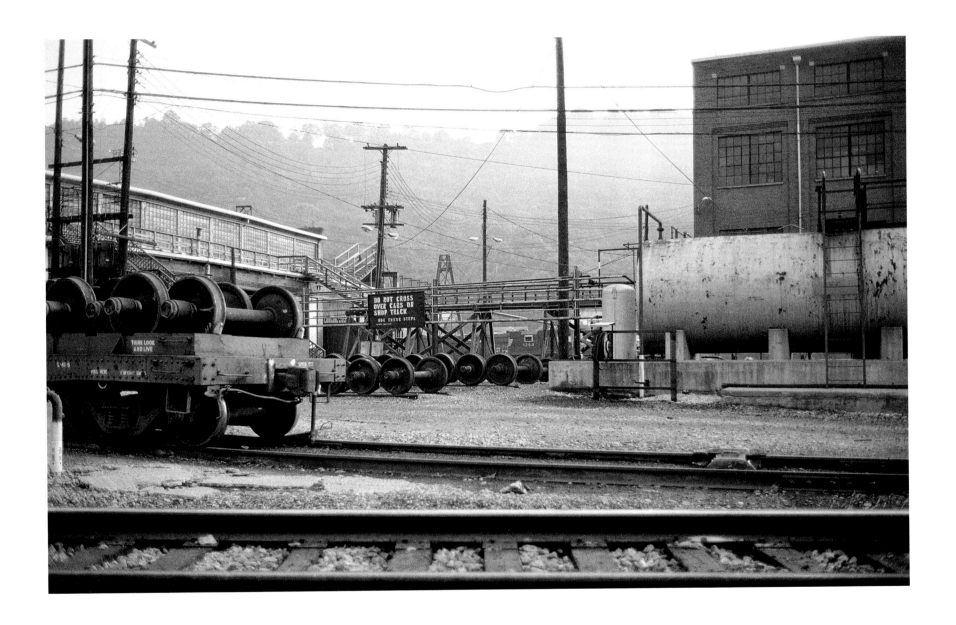

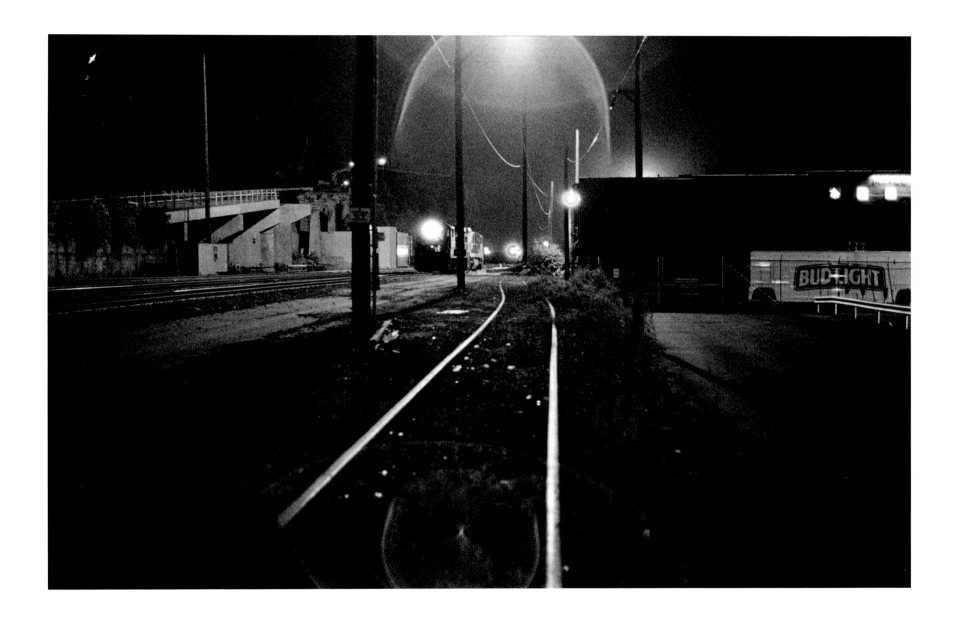

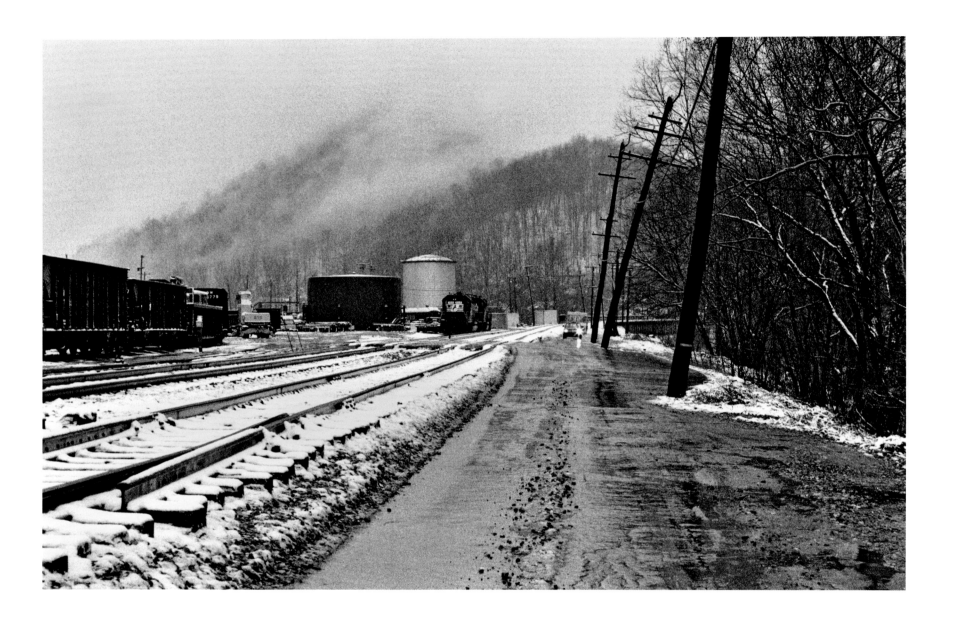

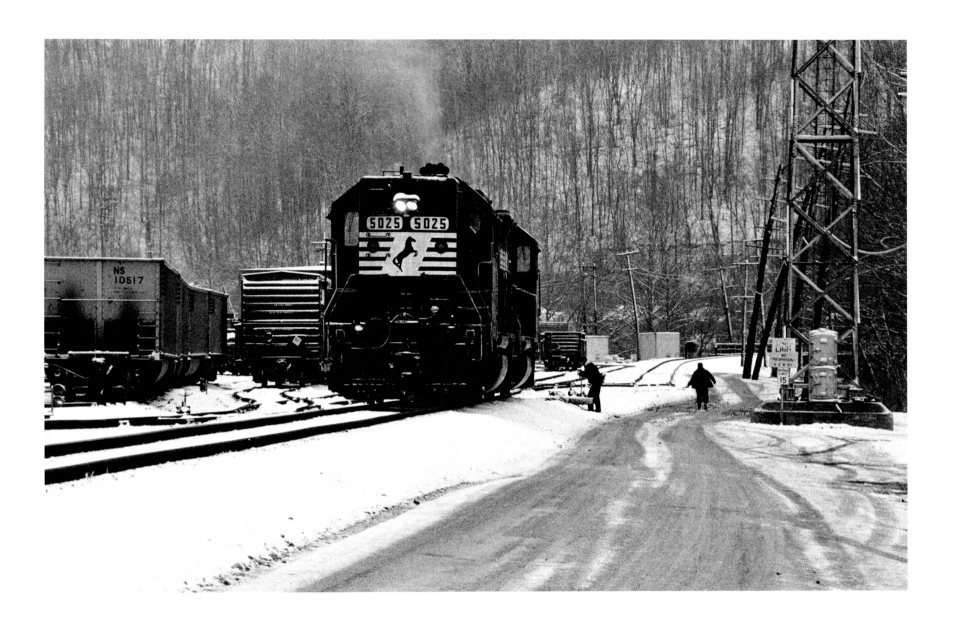

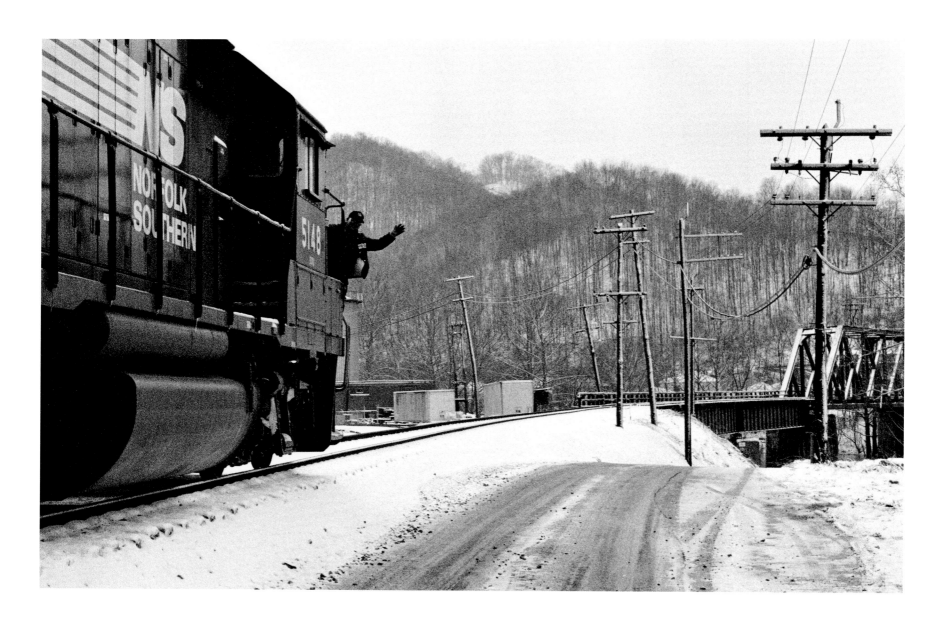

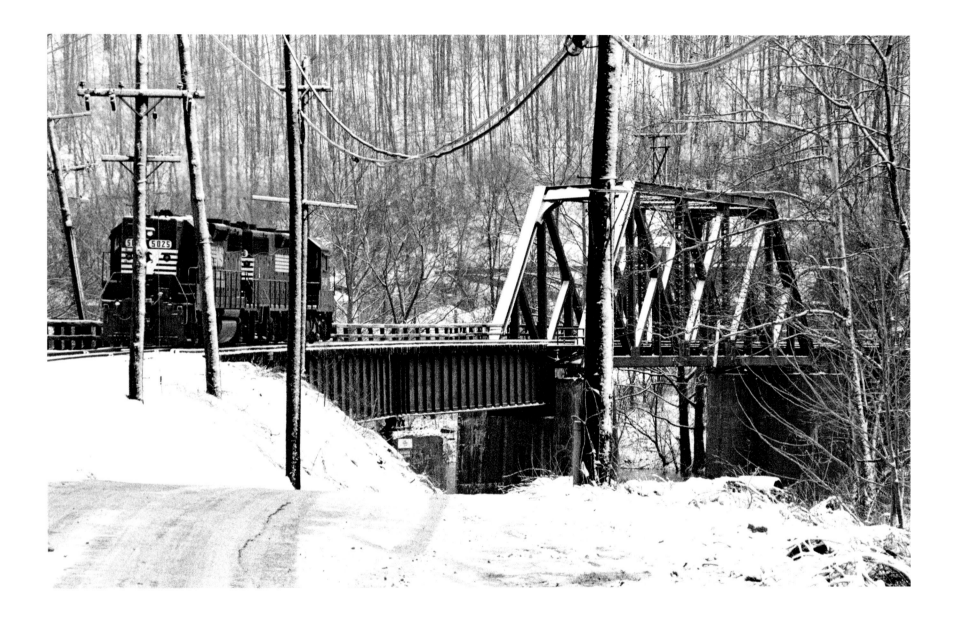

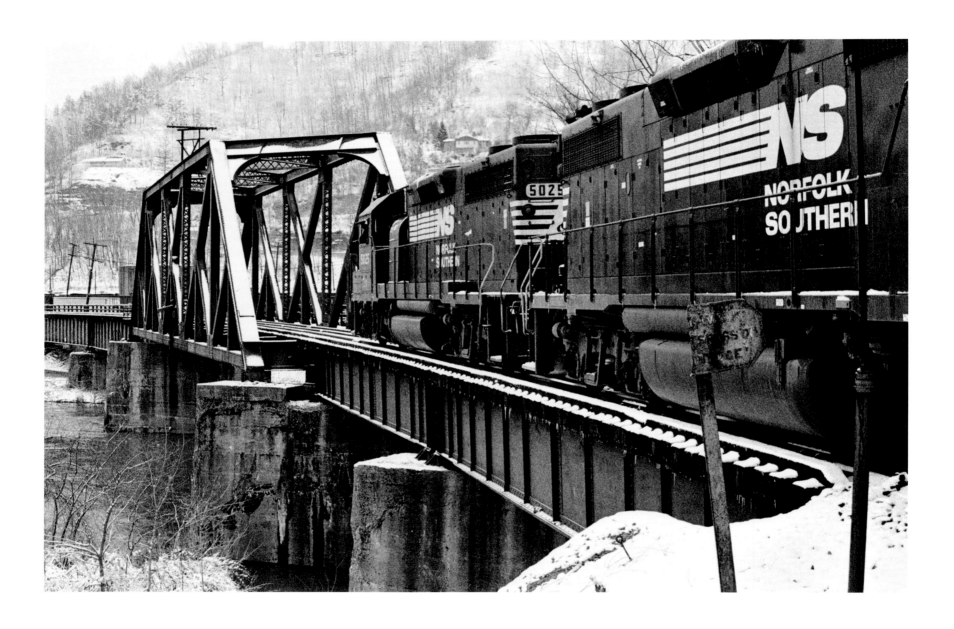

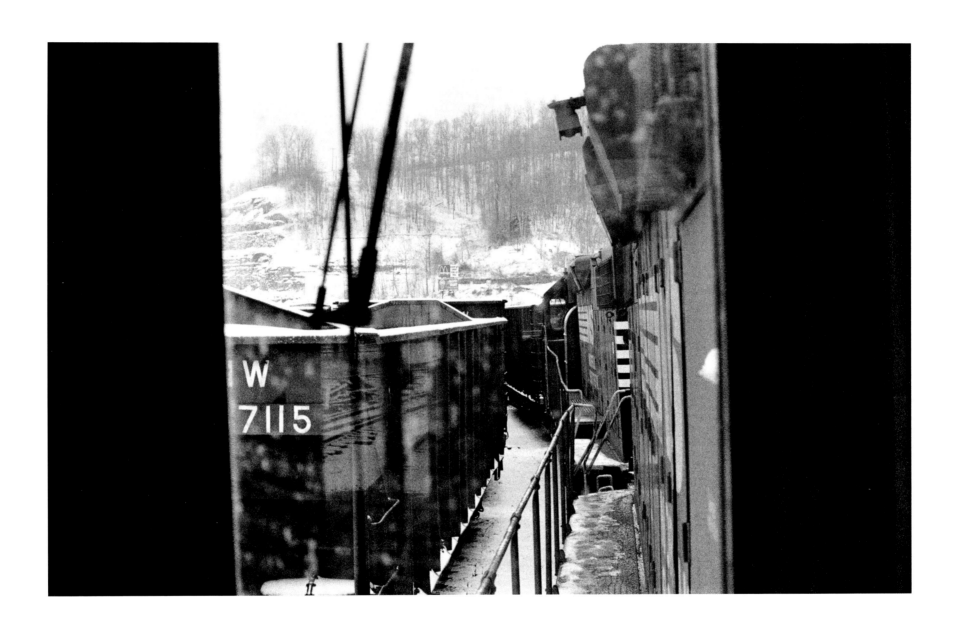

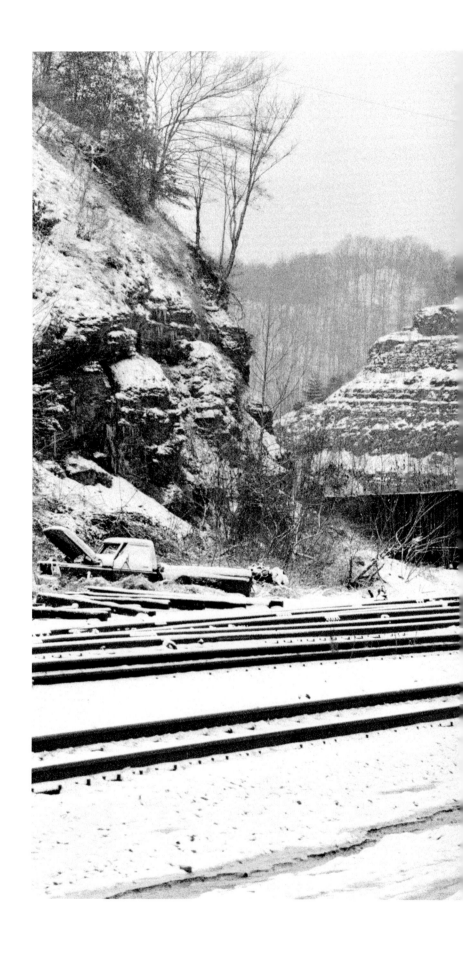

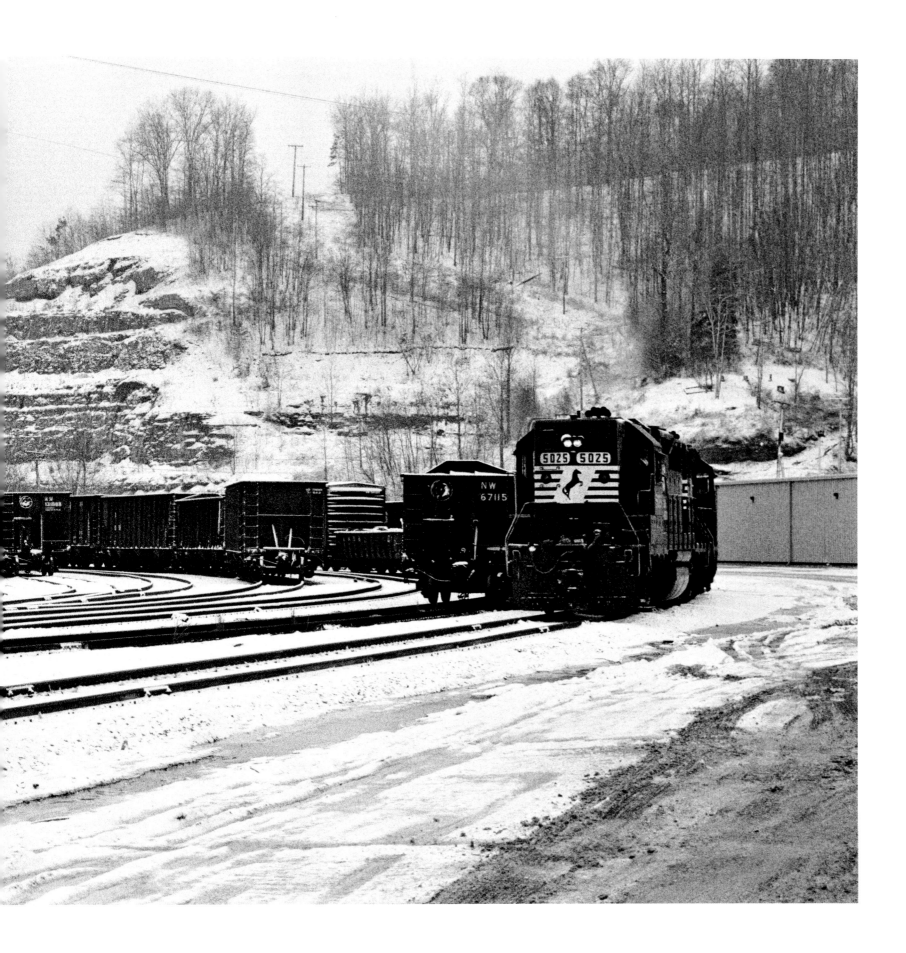

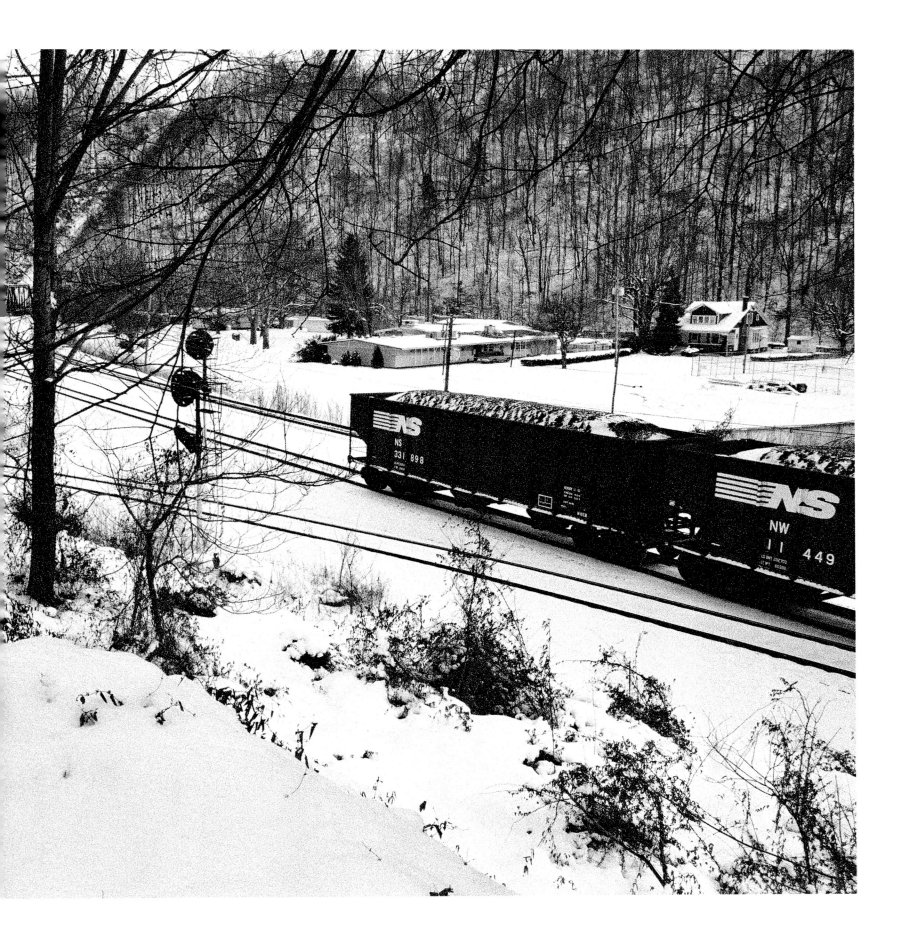

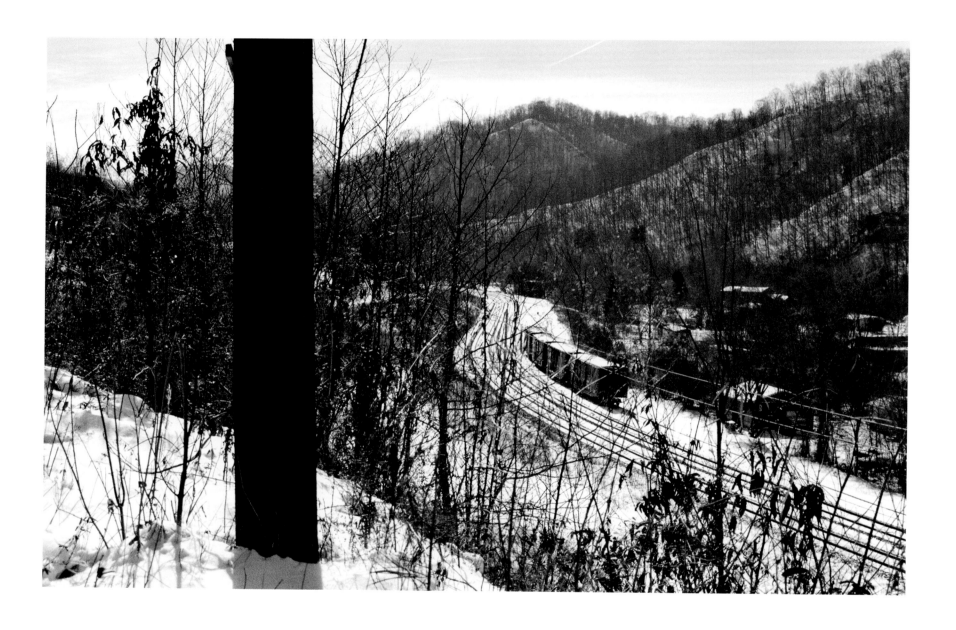

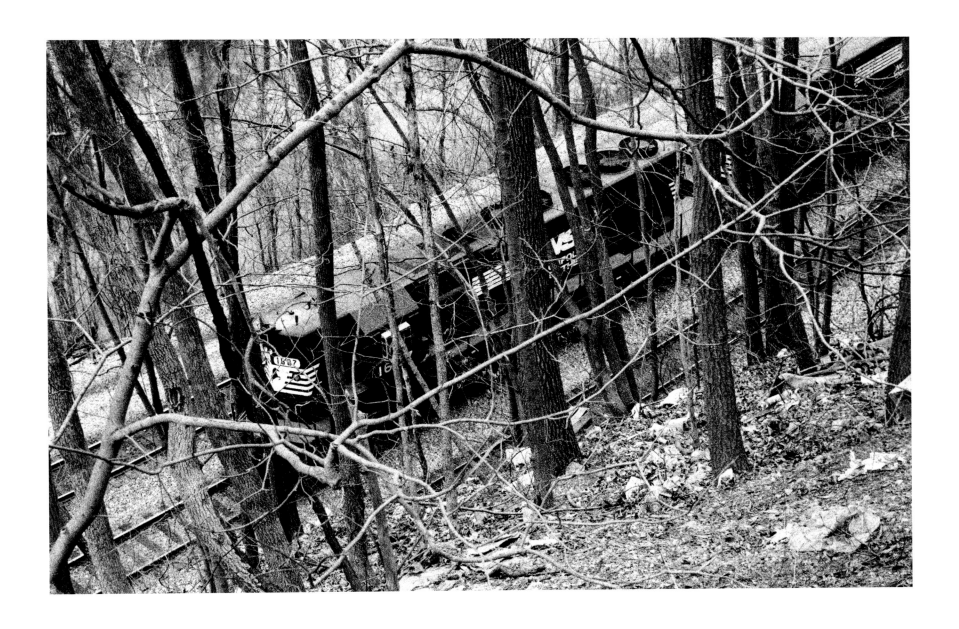

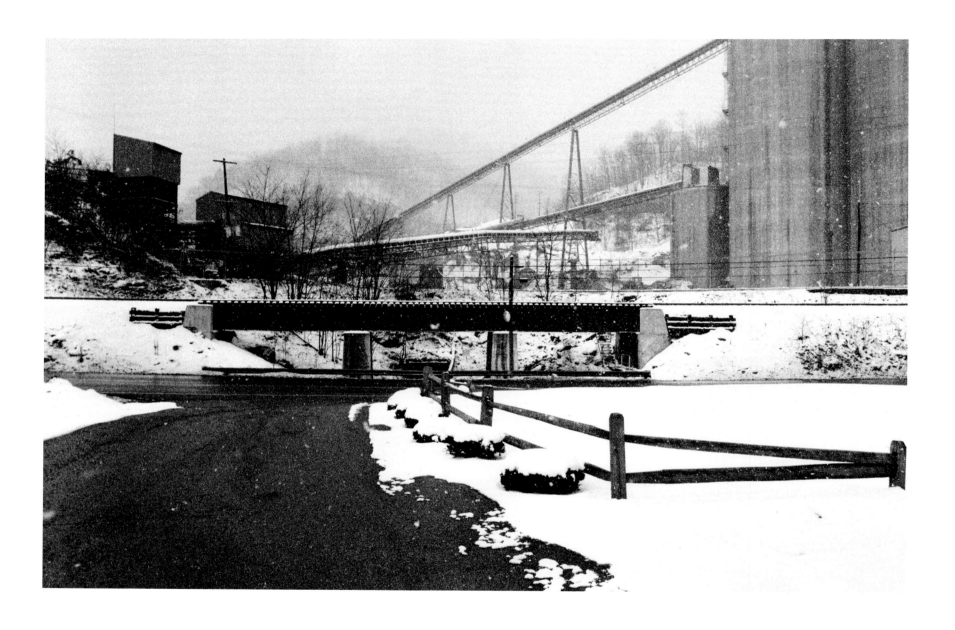

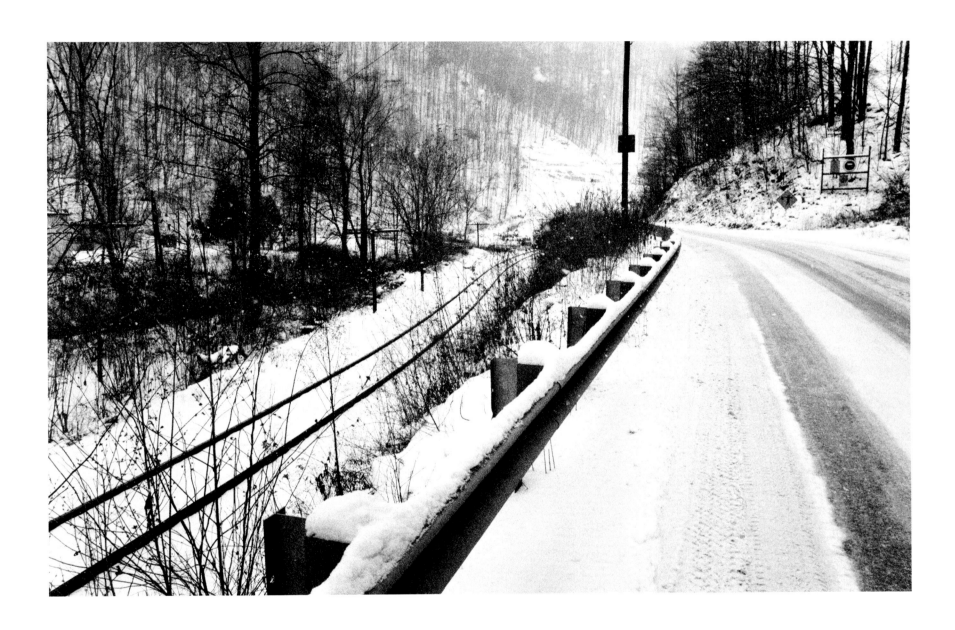

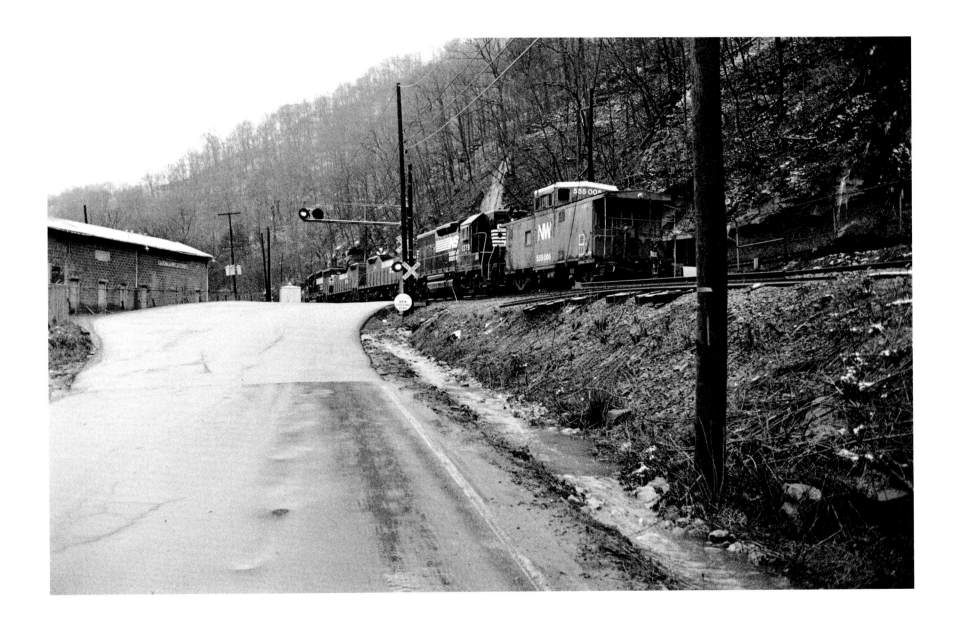

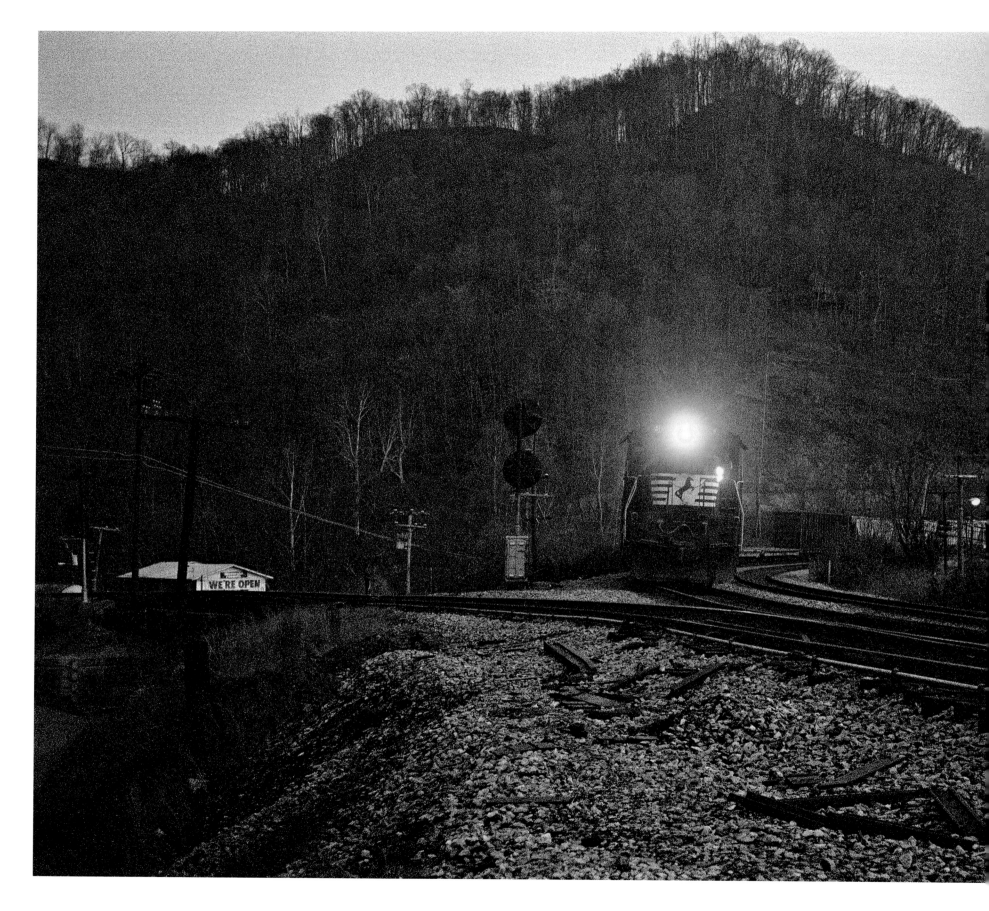

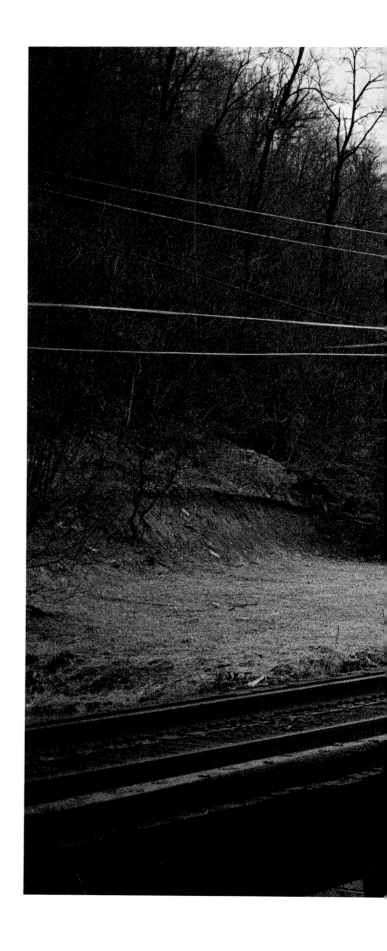

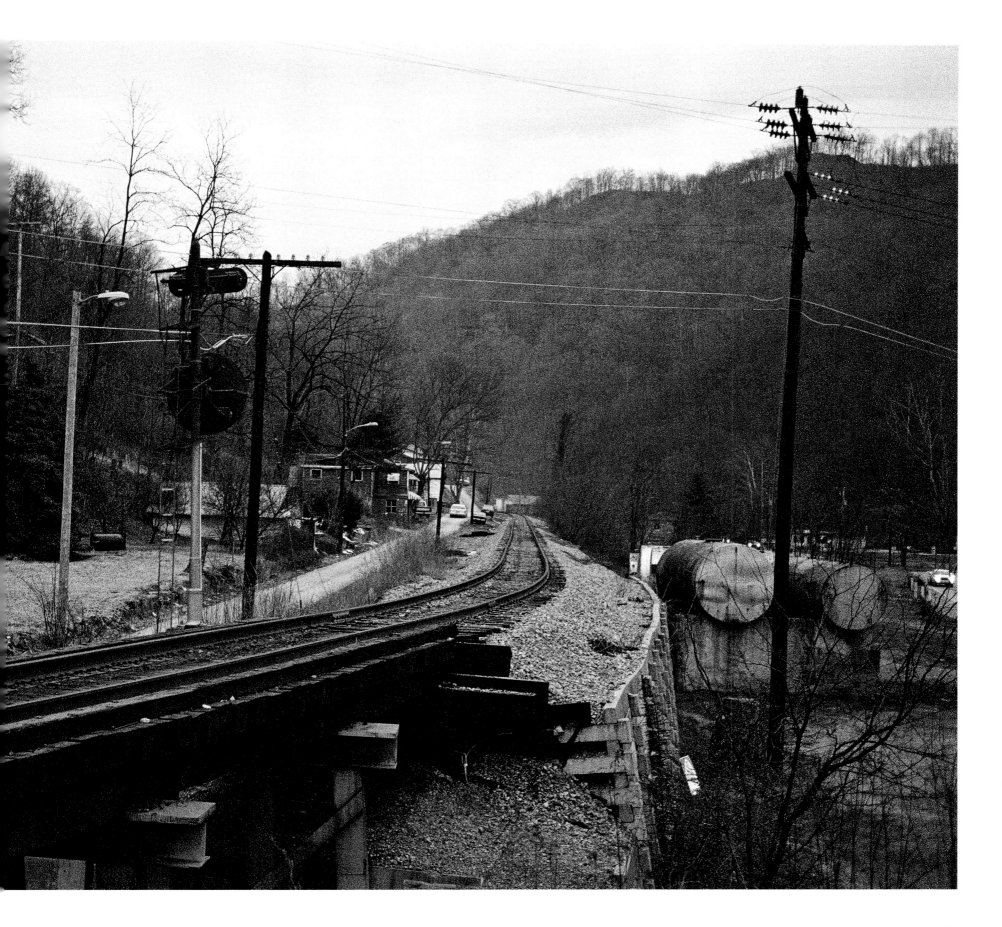

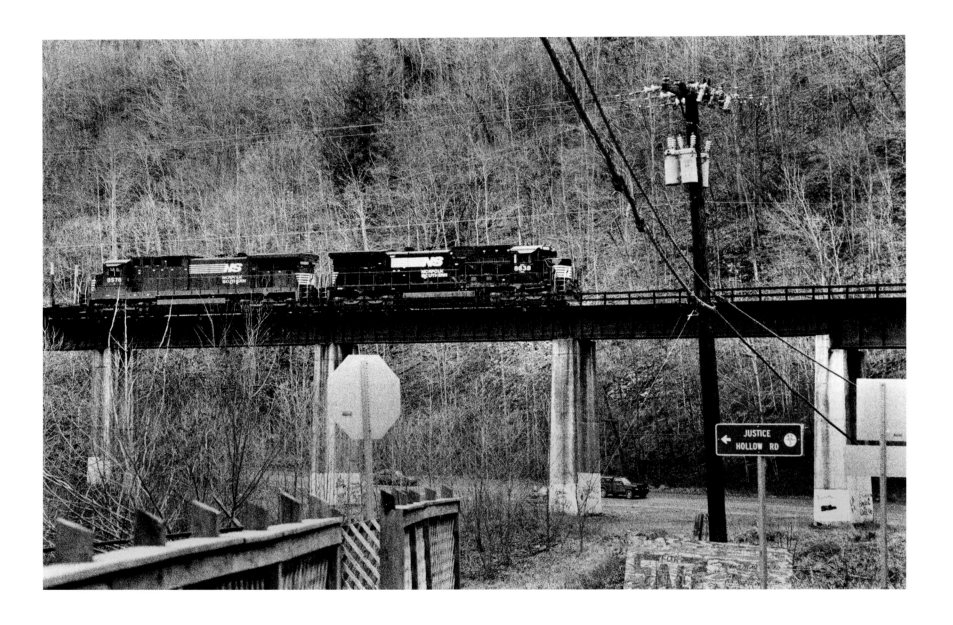

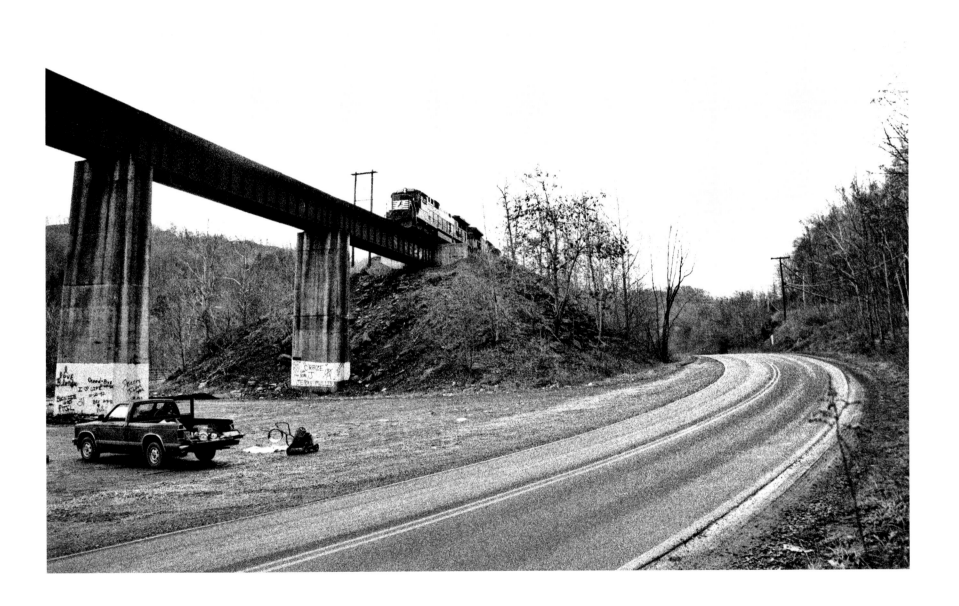

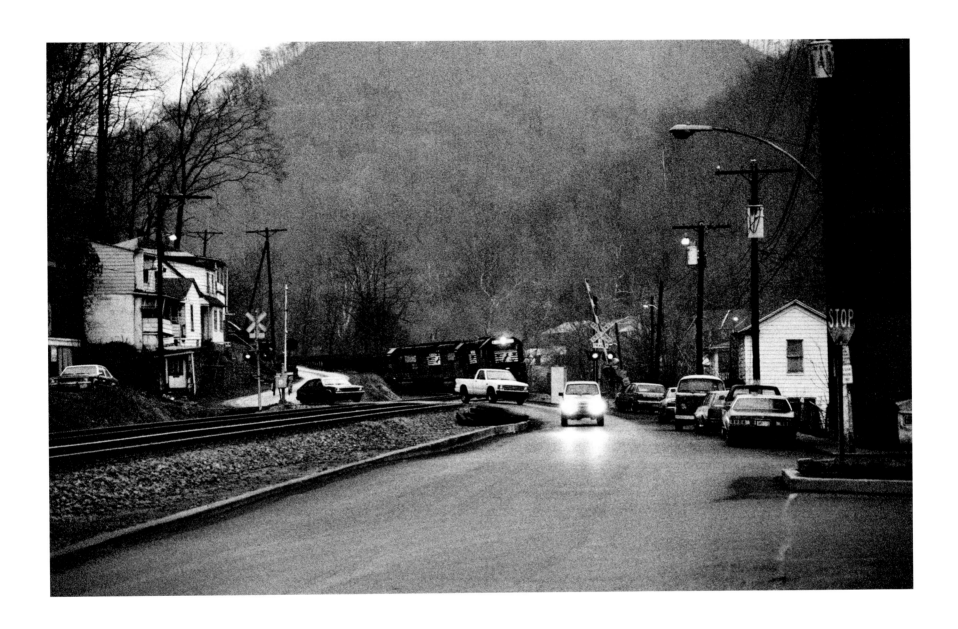

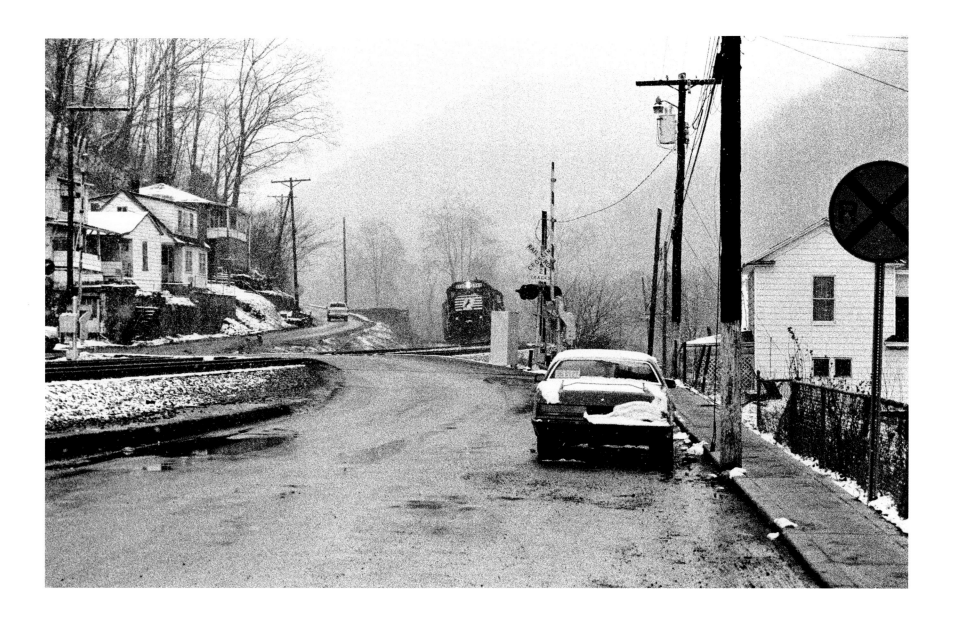

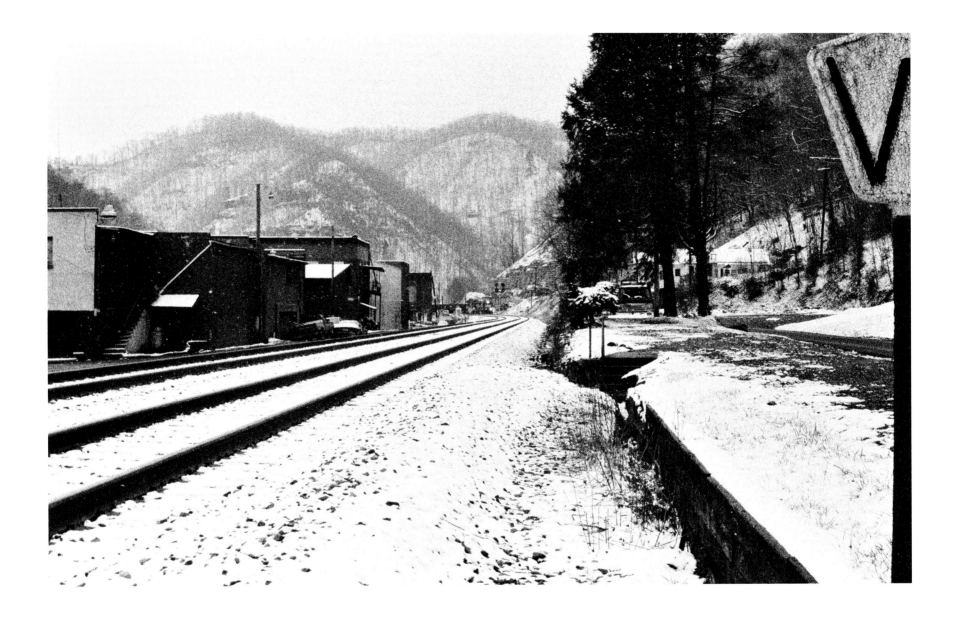

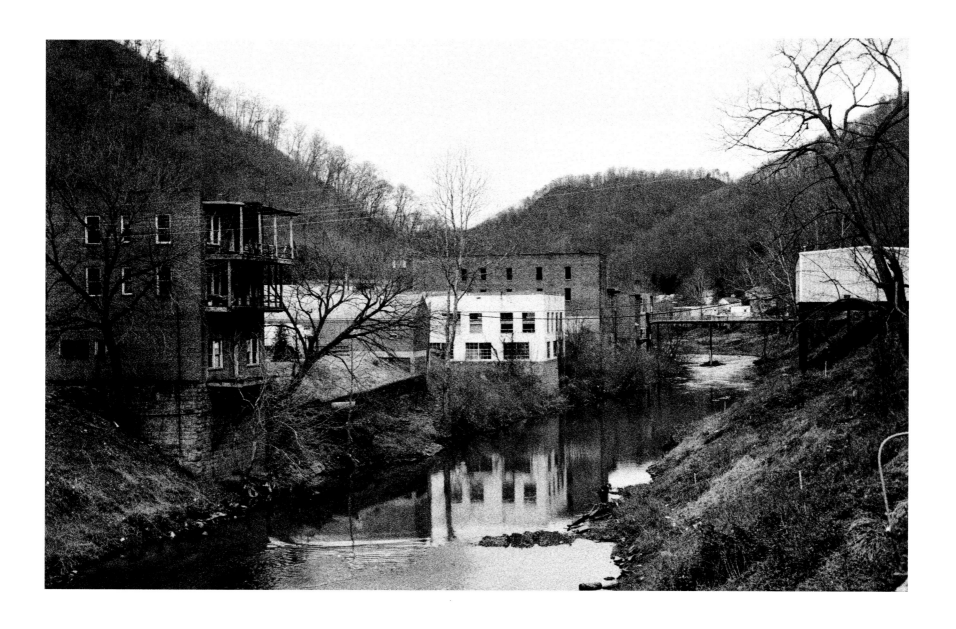

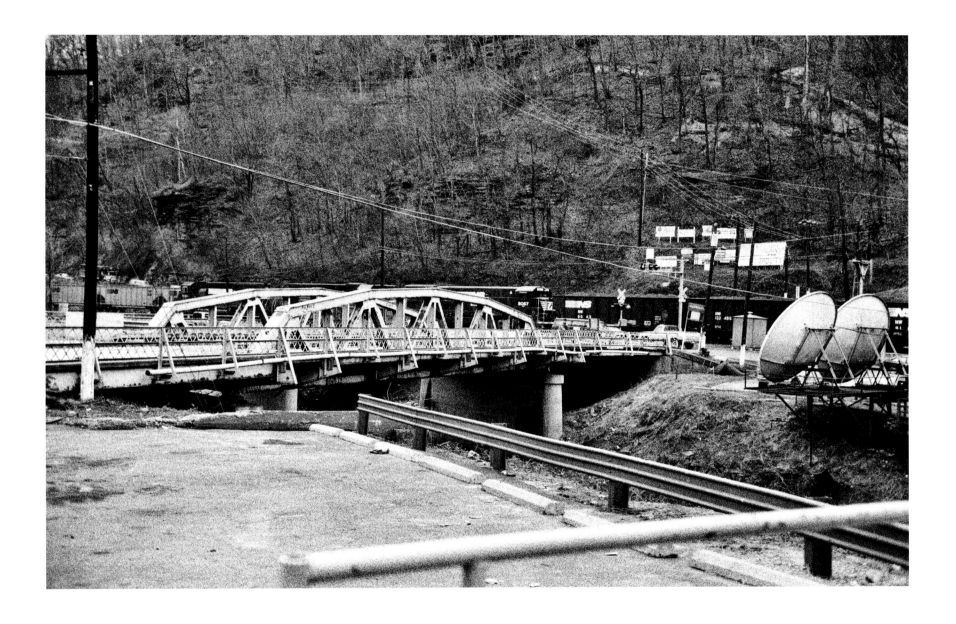

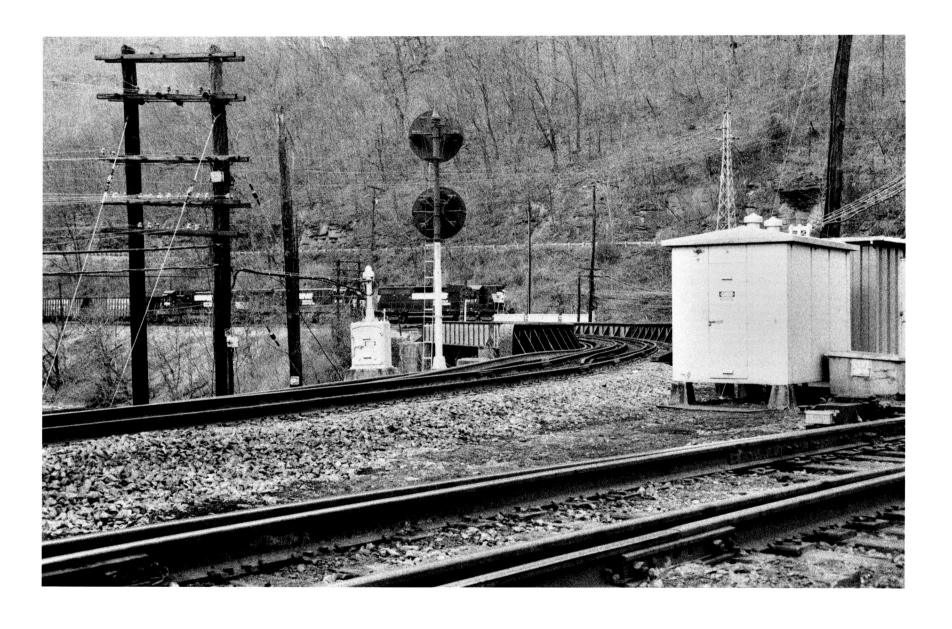

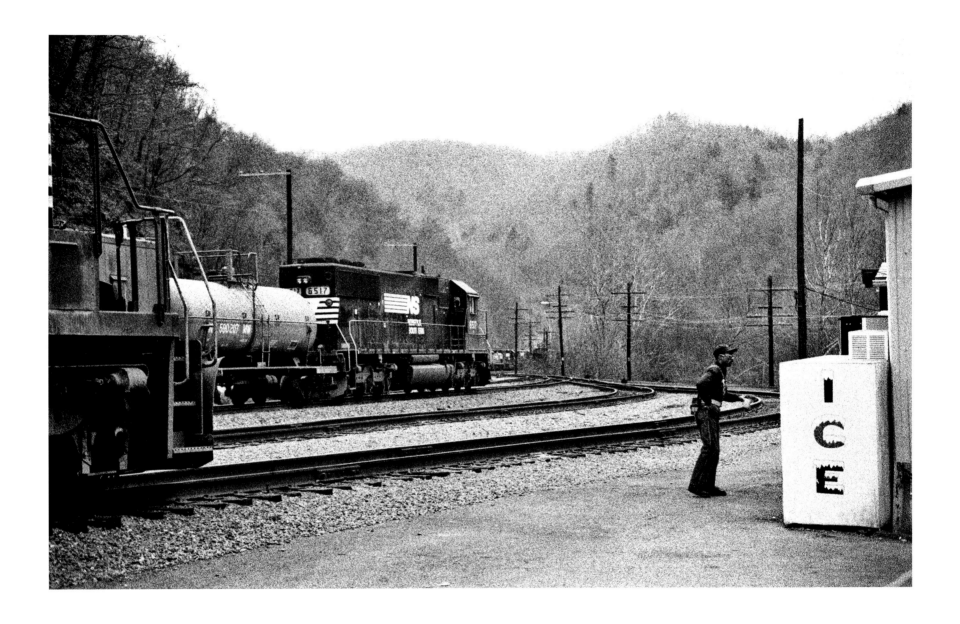

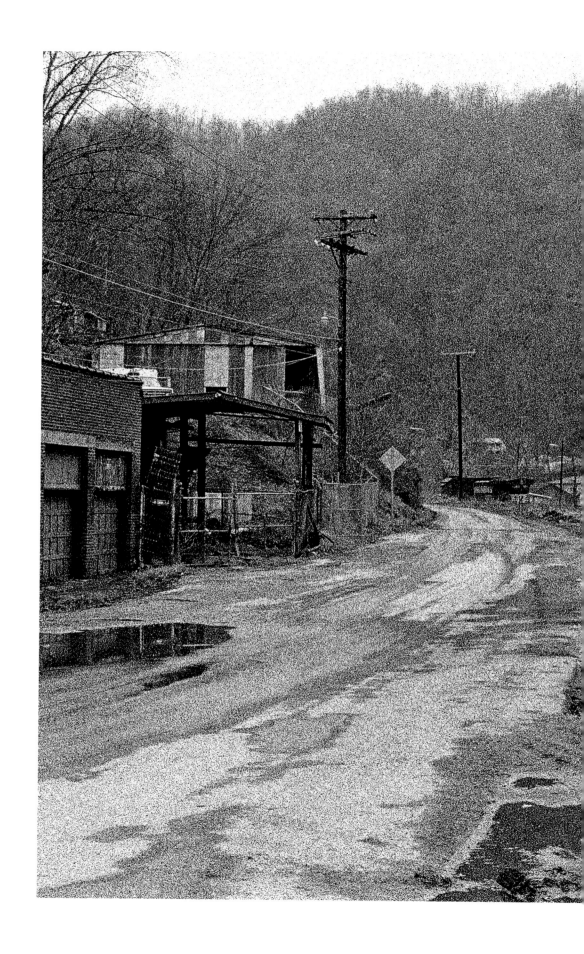

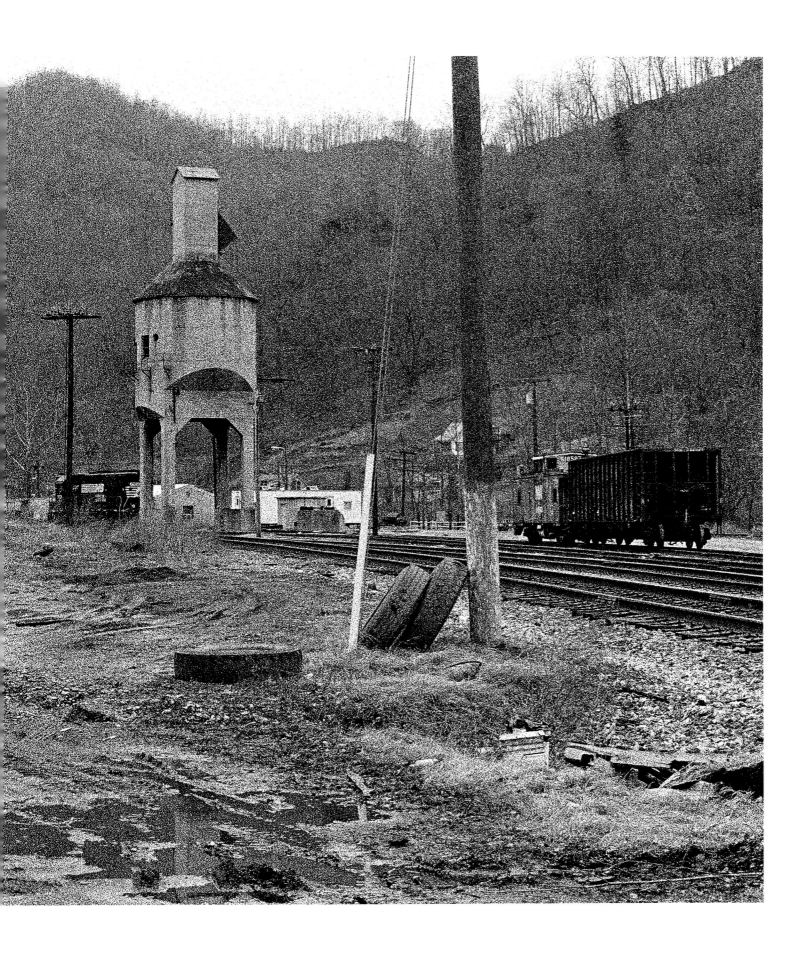

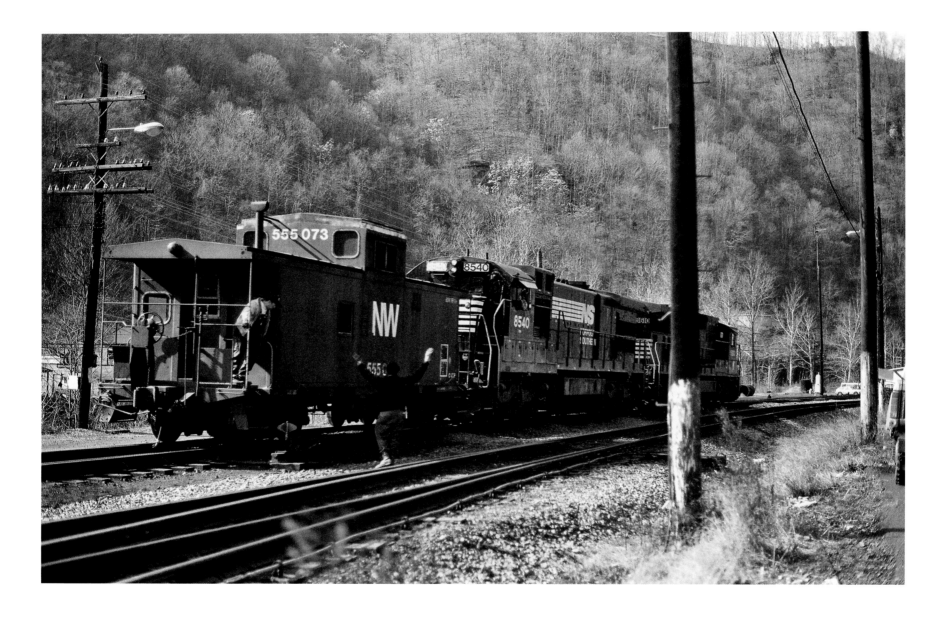

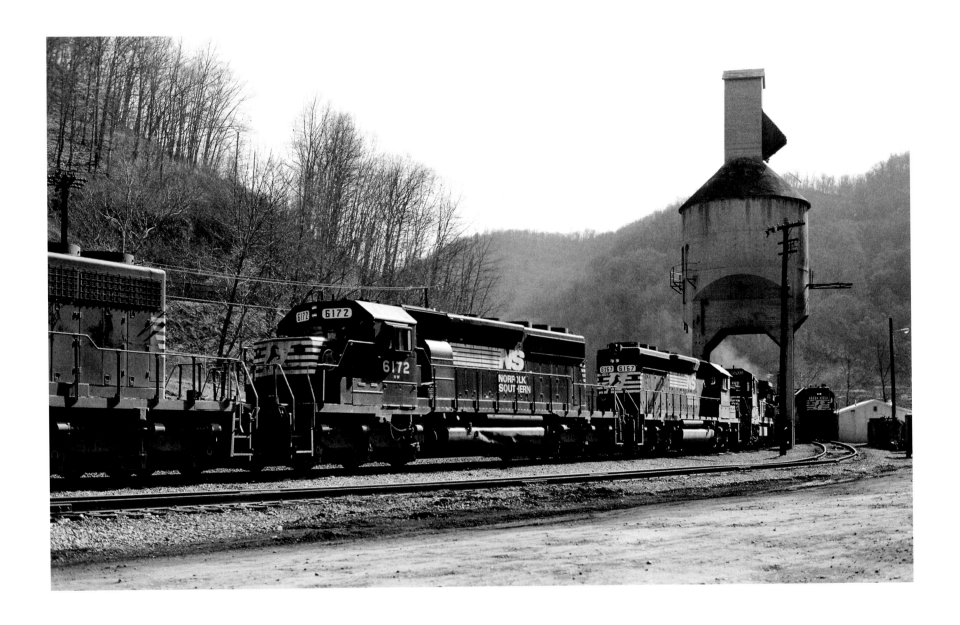

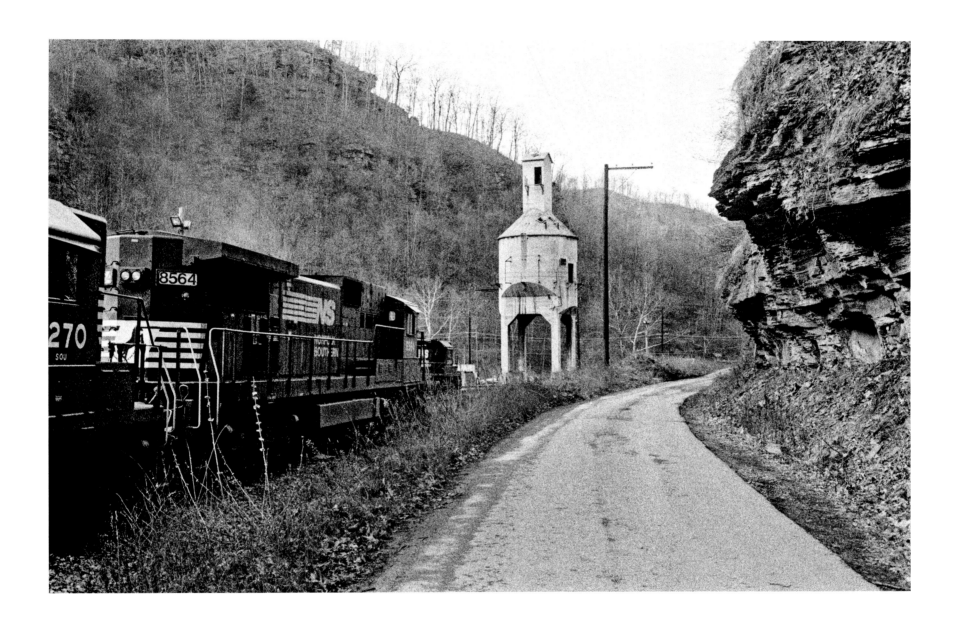

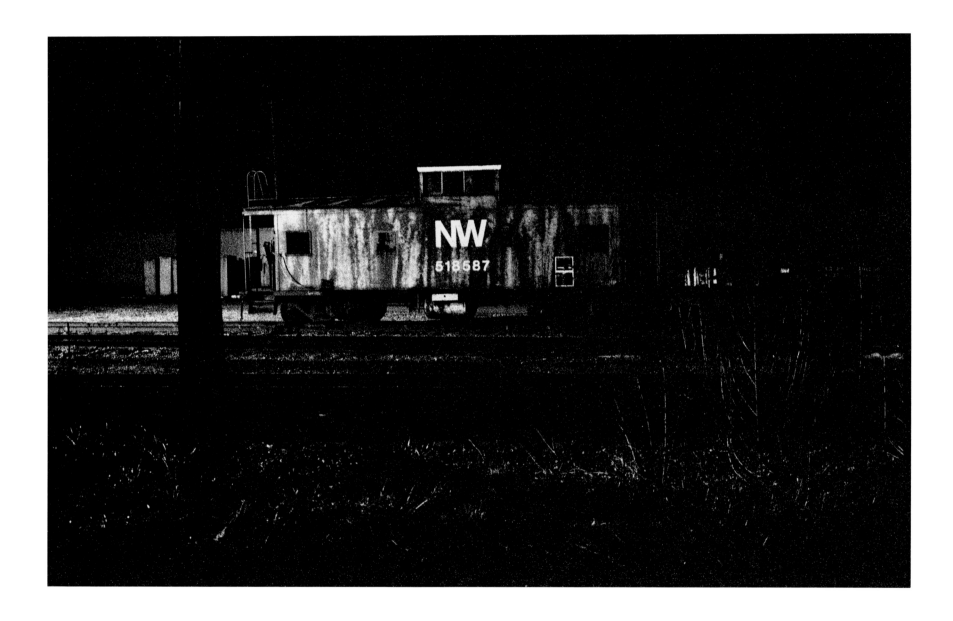

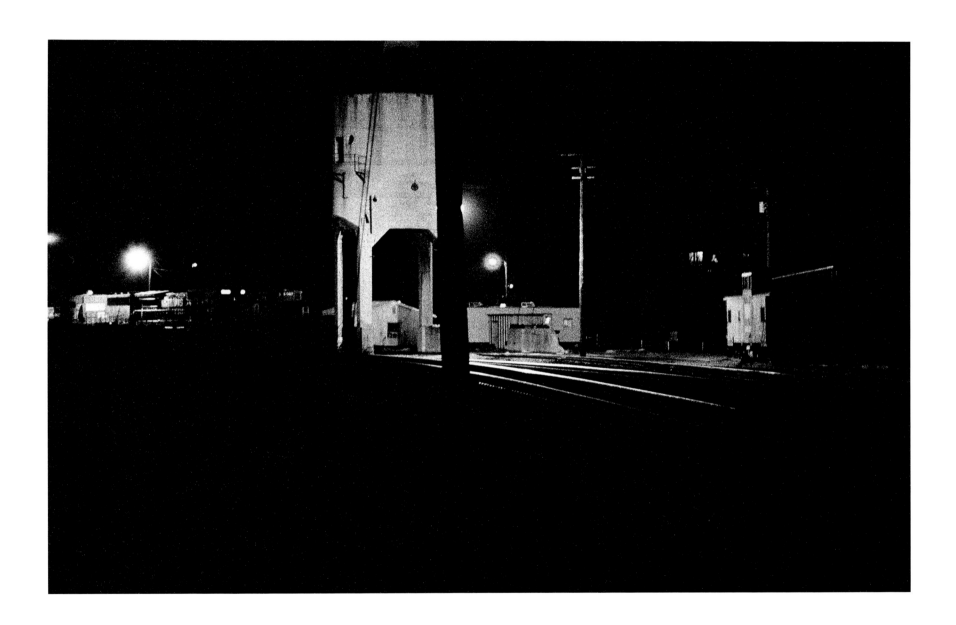

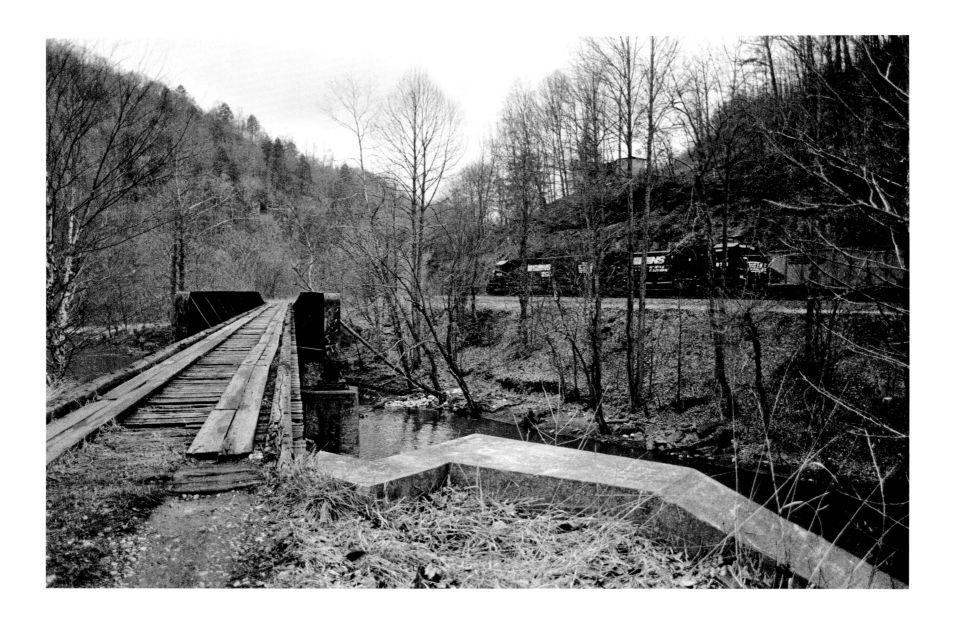

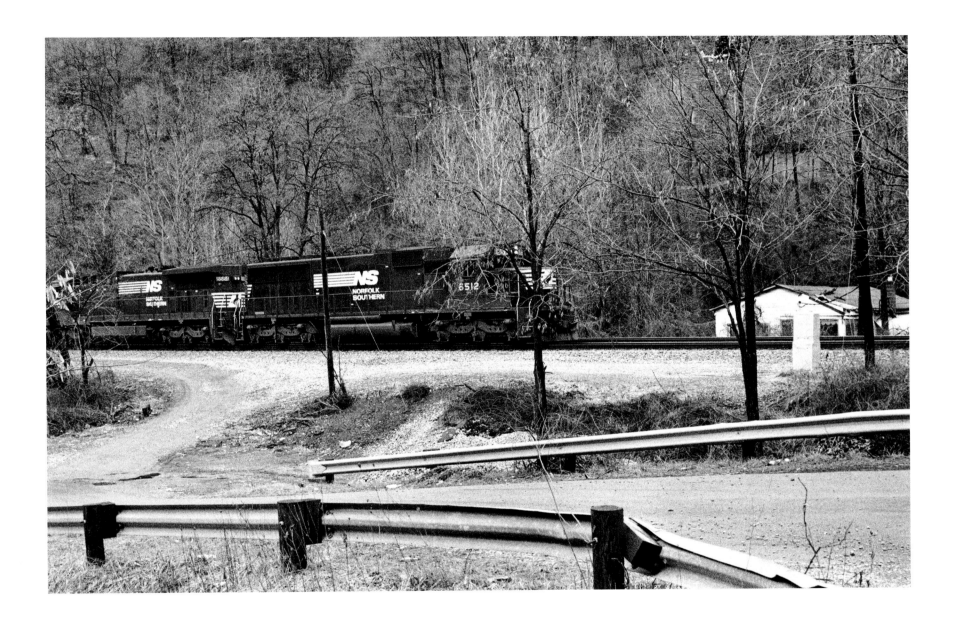

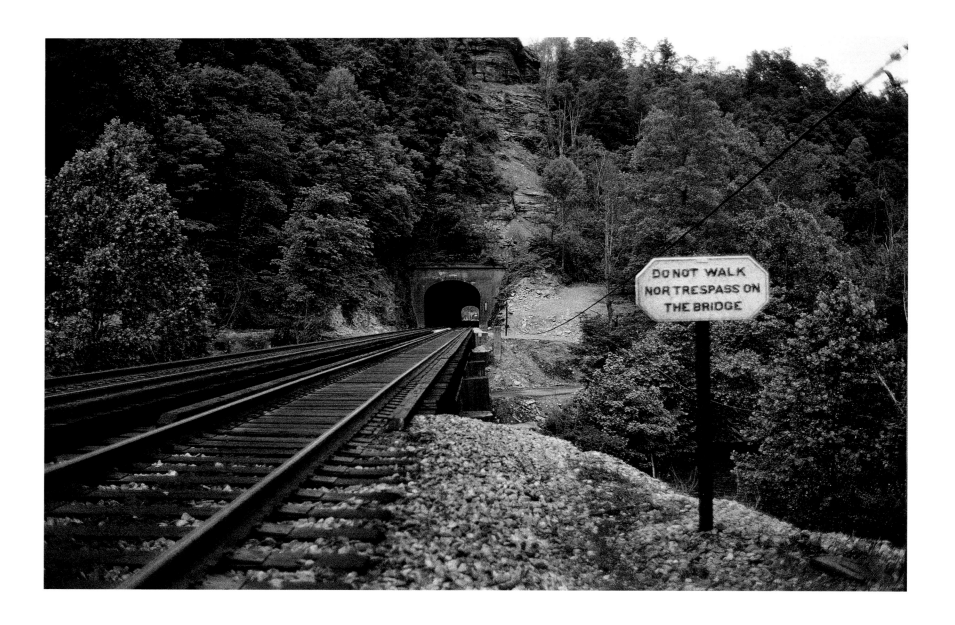

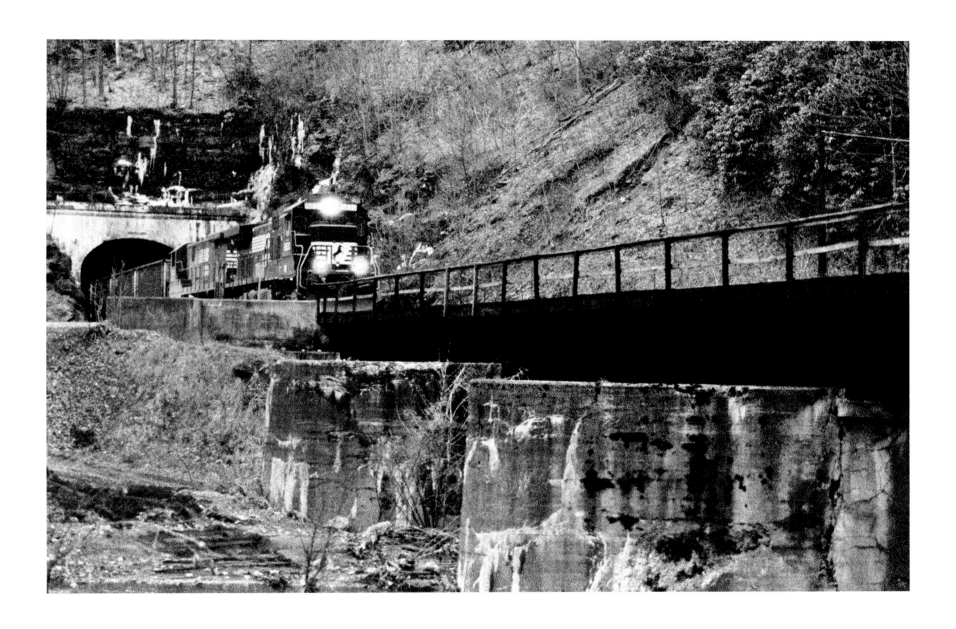

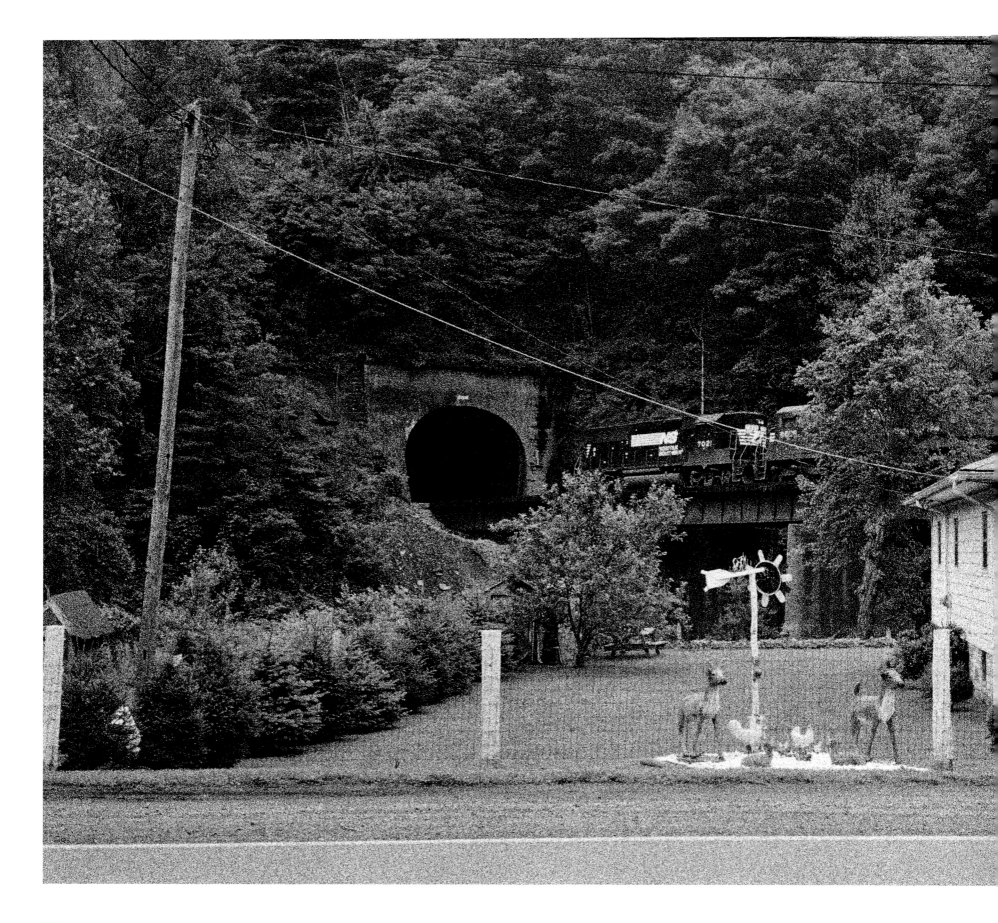

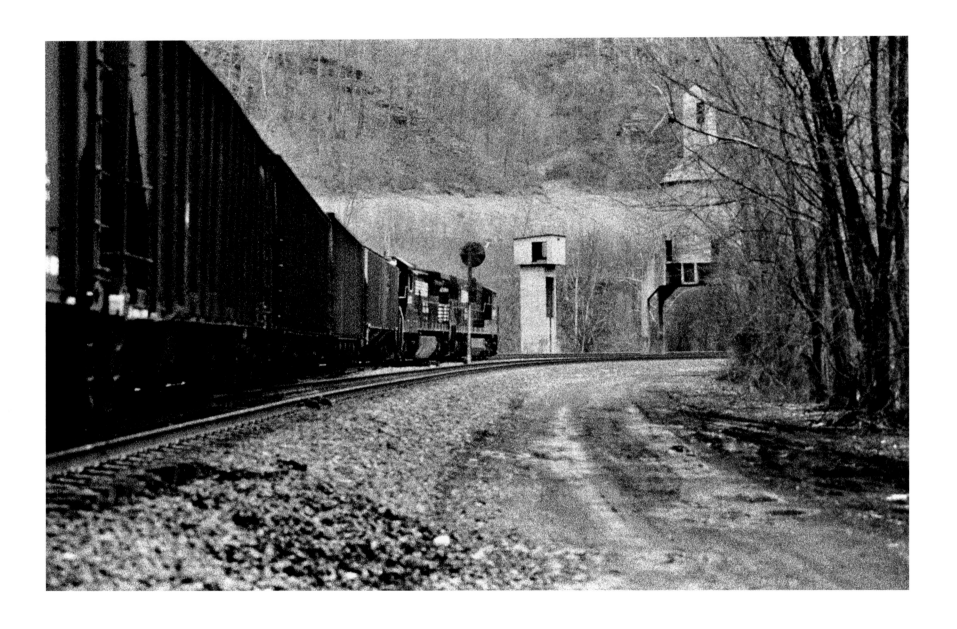

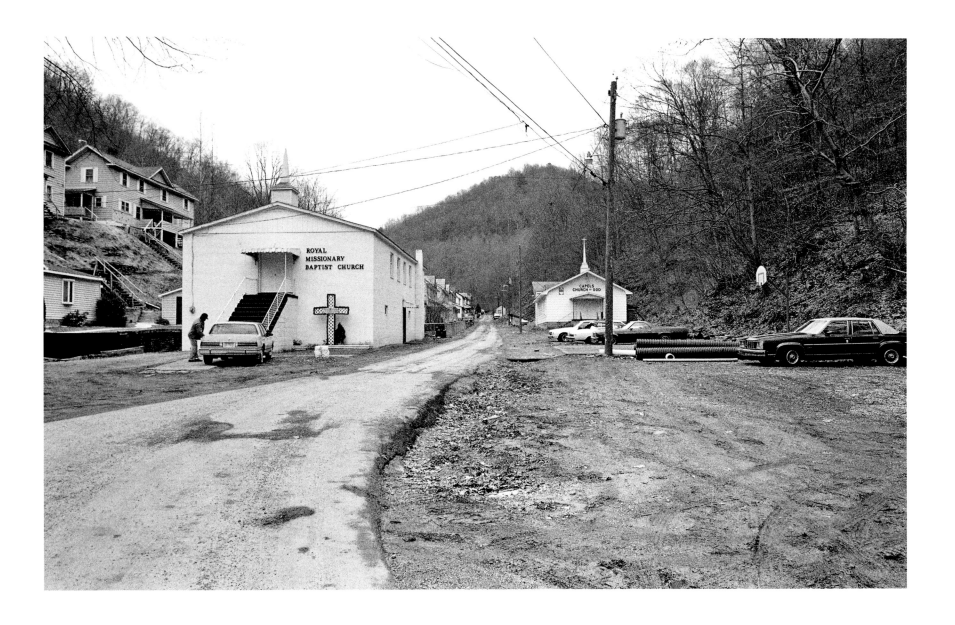

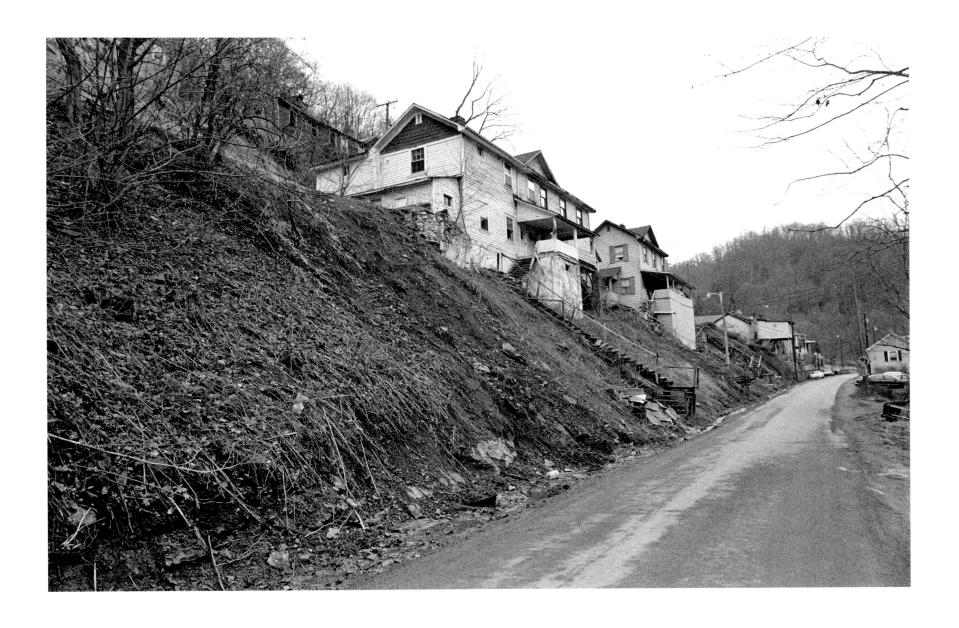

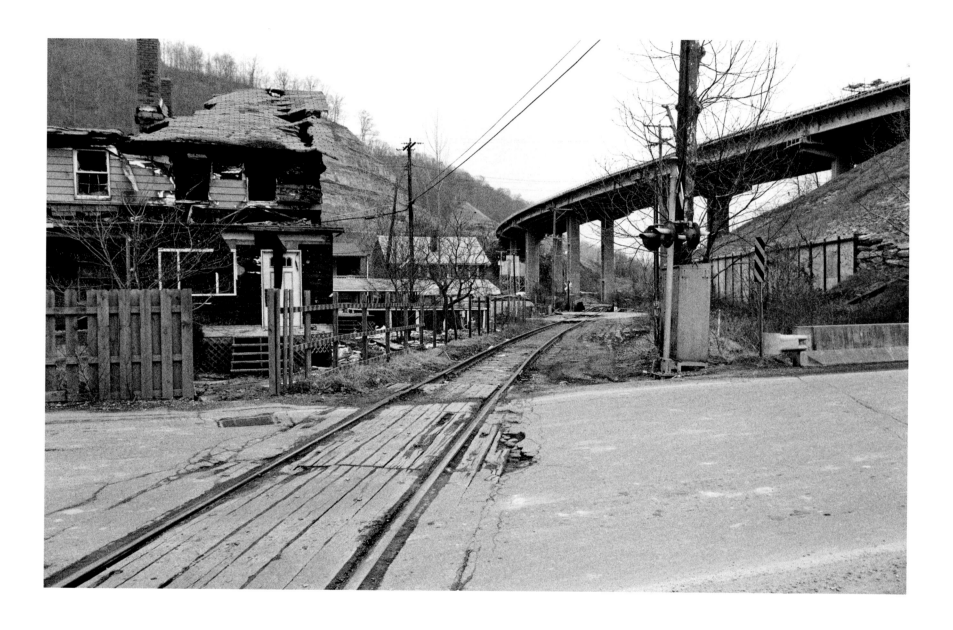

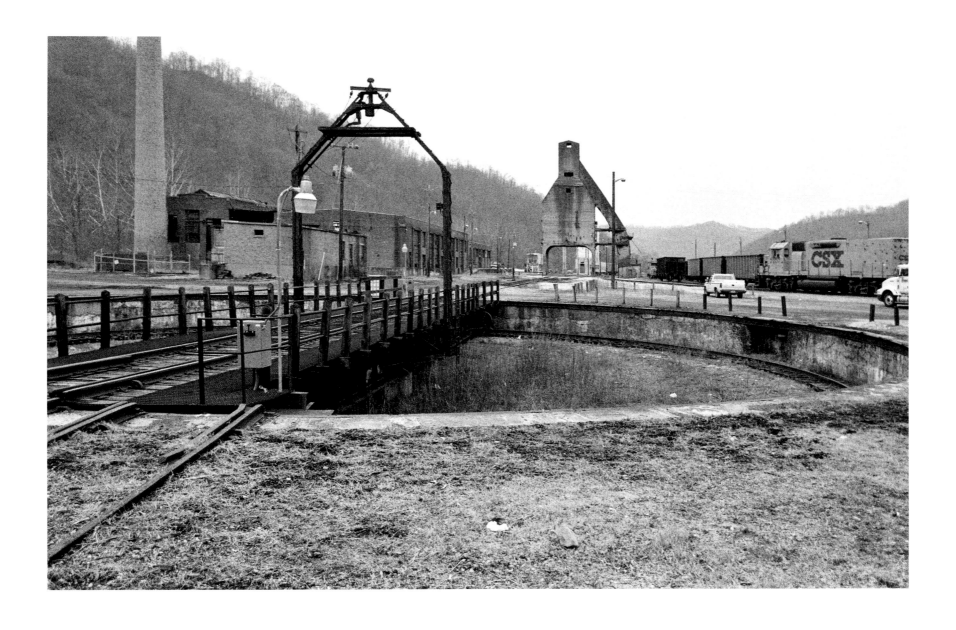

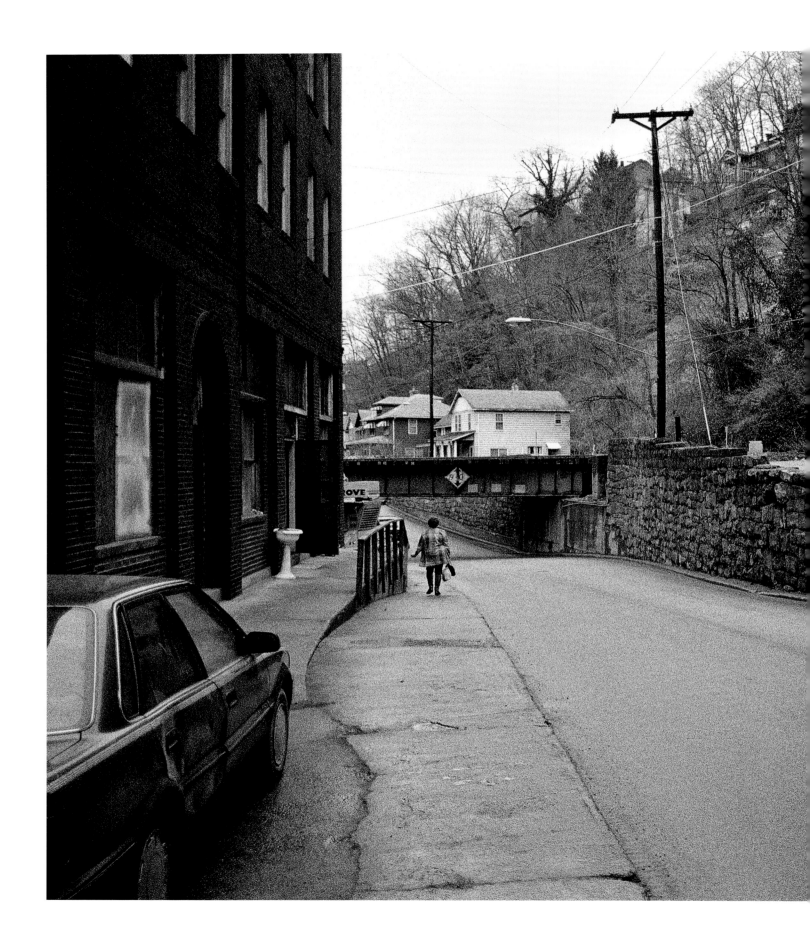

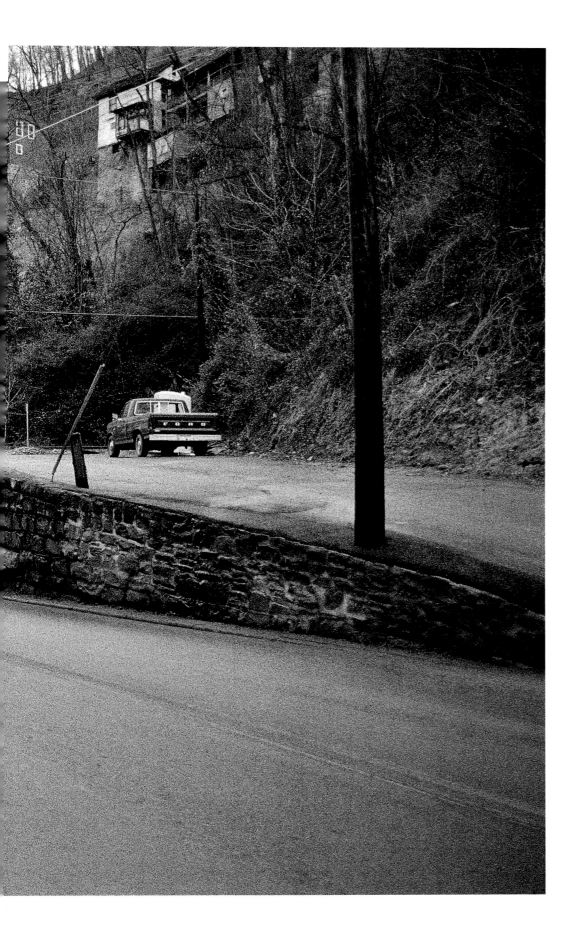

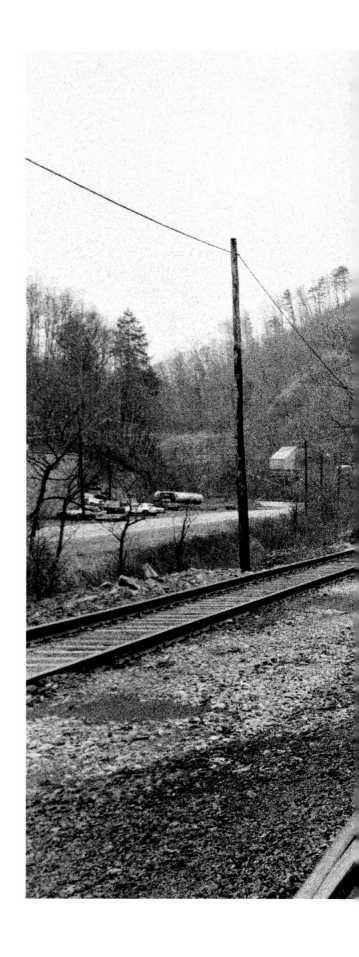

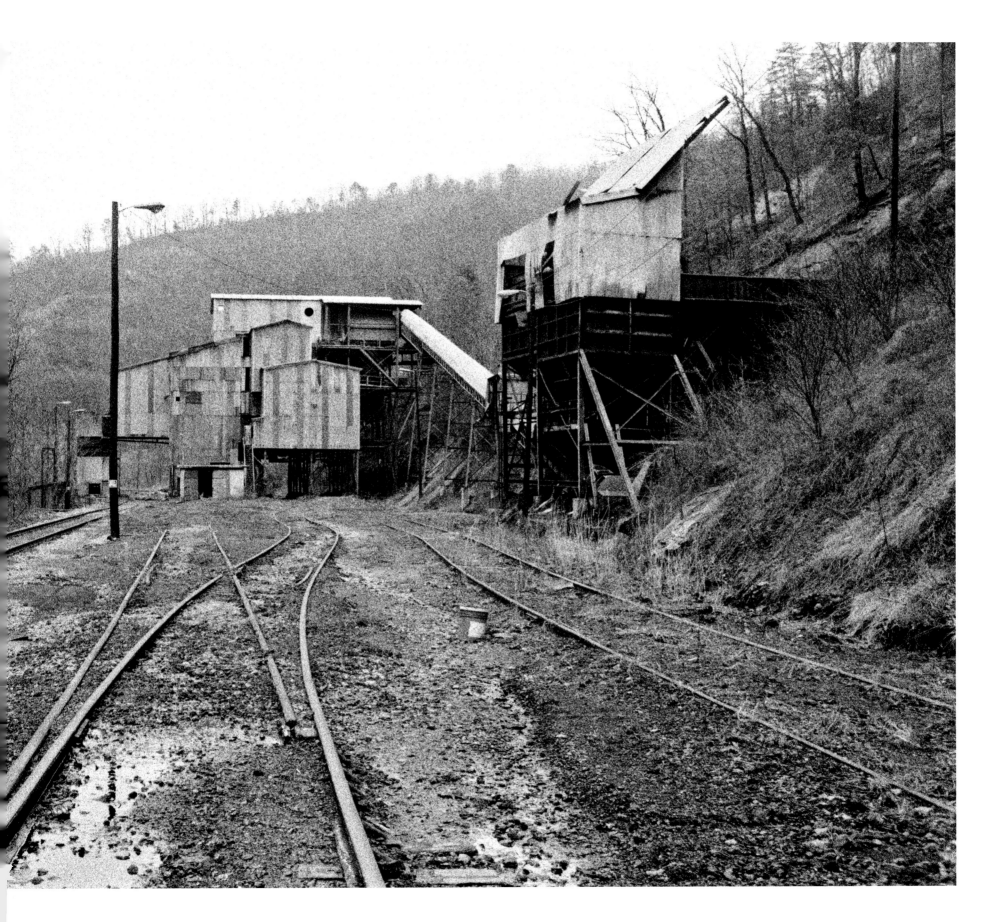

An Edenic Return No Longer Possible

Jeff Brouws

A FRAMED PHOTOGRAPH BY MARION POST WOLCOTT hangs on the studio wall above my desk—an image taken in 1938, near Scotts Run, West Virginia. A string of dark coal cars slants toward the picture's central vanishing point where another black mass—the familiar outline of a mine tipple situated in the photo's middle distance—visually anchors the composition. Dilapidated, clapboard-sided, company-owned housing borders and demarcates the right side of the frame. Low, and slightly off-center, a young girl—perhaps seven or eight years of age—carries a kerosene can. She wearily heads home, slack-shouldered and stooping from the can's cumbersome weight, as a crepuscular light begins to fall (figure 2).

This scene—a gray, rural tableau ringed by low hills and tinged with a sooty presence—was a photograph shot by Wolcott on 35mm film, atypical for an artist who normally wielded a 2¼ or 4 x 5 camera in the field when working for the Farm Security Administration during the latter stages of the Great Depression. This picture is a touchstone of the documentary tradition, as one of hundreds of images made by Wolcott in the border region between Maryland and West Virginia over a four-day period in September 1938. In understated fashion it captures a "sense of place," resonates with social history, and displays a compelling

composition. That the image could easily have come from David Kahler's Leica M6 35mm camera is a given, as if he too had been standing alongside Marion on this fall evening, so similar are the two photographers' aesthetic approaches and viewpoints.

But the comparison doesn't stop there. The additional constellation of elements found in Wolcott's Scotts Run photograph also characterizes many of Kahler's best images: in his work we see a broad, perceptual awareness of the railroad environment and how it interacts with human agency, an affinity for detritus and decay without nostalgic overlay, a graphic eye attuned to compositional possibilities, and an abiding interest in the vernacular and industrial architecture that sits astride the main lines and meandering branch lines he encounters. All conspire to create what Kahler terms "the railroad and the art of place."

In fact the image Kahler calls "The Sound and the Fury in the Garden"—the title conflating and referencing both William Faulkner's novel and Leo Marx's tome on the intersection of technology and nature (see Kahler's Introduction, pg. 6)—echoes and updates Wolcott's "kerosene girl" perfectly. In Kahler's image (figure 1) we see a young, modern mother, presumably without a car or money for gas, walking the mile or two into town for provisions. Pushing a baby stroller, with two other children in hand,

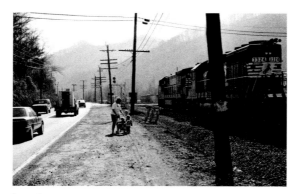 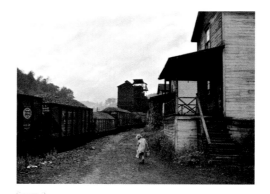

she traces the well-trodden path beside the rail line because it's the easiest way to get there. Dramatically, unexpectedly, three black behemoth Norfolk Southern diesel engines roar past with train in tow—not unlike the massive coal cars towering over a child heading for home in the Wolcott image. While this is Nolan, West Virginia, circa 1992, Scotts Run—as seen in 1938—seems not so distant or different in time, tone, or circumstance. The railroad that dominates the scene in both photos is in fact the main actor on the stage, simultaneously representing both the constant and change-agent in the garden, regardless of era.

TODAY, A QUIET POVERTY INHABITS PARTS of West Virginia and Kentucky as it has for the past 90 years. This impoverishment, often out of view, envelops segments of the rural countryside like a slow-growing, intractable cancer. Low wages and stalled incomes define these places. It scents the air as a way of life, like coal smoke floating above the hollows on a Sunday morning's wintry dawn. Many of Kahler's images capture this ineffable mood successfully. The extractive industries have pillaged the landscape in order to feed a nation hungry for energy resources. The railroads, right behind them, have also profited by moving the merchandise to market. In both cases, not much of that wealth got

transferred to the miners, or train crews, that dug or transported the coal. Aptly, Kahler symbolically captures these hard realities on film; the railroad is seen running through the garden, but is not of the garden.

With these thoughts in mind, Kahler came to the region in 1992 on an exploratory mission. Searching for photographs along both states' rail lines—rights of way that ran by rivers and sliced through hills, hamlets, and villages—he had a feeling that the end was already foretold, the land adjacent to the railroad speaking to him, revealing what was to come. Townscapes and industrial infrastructure seemed worn out, exhausted, and near collapse. "Creative destruction," a favorite term of Kahler's, was manifest everywhere. Paradoxically the chances for evocative photography were plentiful for those attuned to this creeping devolution beside the tracks. To that end, and employing an architectonic approach to picture making, Kahler tends to place aesthetics on equal footing with his subject matter. A now retired architect, how could he not? He sees shape, form, and line intuitively and utilizes these formalist underpinnings to transform the physical reality of the scene before him into dramatic and often surprisingly graphic compositions. This ability to see the "geometry of the everyday" grants him a singular vision. Oftentimes, too, he relegates the

train to the background, making it a tertiary figure in the photo—ironically de-emphasized but better integrated into the overall scene. This also becomes another unique attribute of his visual sensibilities and a signature of his style.

AS WITH WOLCOTT'S WORK, KAHLER had little foreknowledge of other aspects of contemporary photographic practice or history; he was a neophyte in this regard when he began making his West Virginia photographs as well as the Kodak Brownie images taken in 1957. Yet the aesthetics he chose to employ for both the earlier and later work often foreshadowed or paralleled the photos done by David Plowden, the New Topographic photographers from the 1970s, or the Lee Friedlander images found in his book from 1982 entitled *Factory Valleys*. These artists were front-line witnesses documenting the transformative effects of the machine in the garden but seen from different perspectives. In the case of Plowden, he caught the final flowering of steam power in America and composed a heartfelt requiem for same; with the New Topographics photographers it was the buildout of suburbia and its impact on the natural world that captured their attention; with Friedlander it was the de-industrialization then metastasizing across America's manufacturing centers in the late 1970s and early 1980s that drew his focus. Like Kahler, these photographers and movements chose the medium of black and white to tell their stories and did so with acuity. With the same resolve, Kahler compiled his visual record about two railroads—CSX and Norfolk Southern—between Ashland, Kentucky, and Capels, West Virginia, returning yearly from 1992 to 1997. Shooting in gritty monotone, and then purposely intensifying the emotional tenor of his imagery by overexposing T-Max 400 to enhance the film grain, he created images that withheld no truths, with the roughed-up film stock matching the naked and urgent rawness of all he was seeing.

WHILE THE HINTERLANDS OF WEST VIRGINIA hold great beauty, part of the state's geography is also defined by a foreboding abandonment, by a feeling of cultural "left-behind-ness." Kahler's photograph at Iaeger, West Virginia (see pg. 117), speaks to these points. Once a bustling terminal site on the Norfolk & Western, this image captures this elegiac tone, the true essence of Kahler's project. While on the surface it could be read as a quiet lament for that which has passed, this striking image, taken collectively along with the other 109 images in this book, conveys something greater—that the machine despoiled the garden and an Edenic return is no longer possible.

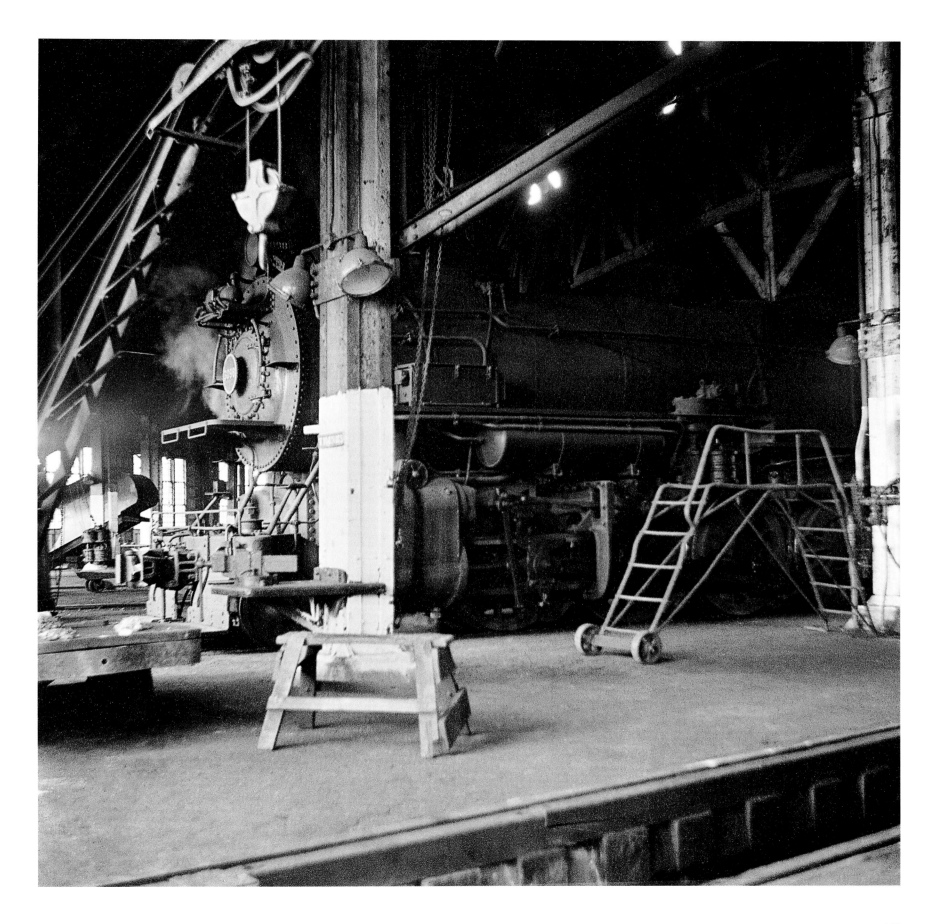

West Virginia and the Railroad

Scott Lothes, Executive Director
Center for Railroad Photography & Art

THE RAILROAD HAS DEFINED WEST VIRGINIA like few other places. The state owes part of its very shape to the presence of the railroad. West Virginia, with its jagged border and two jutting panhandles, gained statehood during the Civil War in 1863, after western Virginians elected to form their own state and remain loyal to the Union. The new state's eastern panhandle, a narrow strip of land carved out of Virginia immediately south of Maryland, contained the strategically vital Baltimore and Ohio Railroad (B&O). The inclusion of the eastern panhandle in West Virginia placed the railroad entirely under Union control.

There were deep divides—geographically, politically, economically—between eastern and western Virginia long before the Civil War. Prior to the coming of the railroads, the Allegheny Mountains formed an almost impenetrable barrier between the broad valleys and rolling hills of eastern Virginia, and the deep gorges and narrow hollows to the west. Many European settlers came down into that frontier from western Pennsylvania and states farther to the north, establishing a population that had few connections to Virginia's major cities in the east. Plantation-based agriculture was entirely unviable in western Virginia and its residents felt increasingly ignored by the state's policy and lawmakers in the capital city of Richmond.

Those early settlers of what would become West Virginia were largely protestant Germans and Scots Irish. Seeking religious freedom and land to call their own, they found a hardscrabble existence on isolated mountain farms. Their lives were often difficult and hand to mouth, but they had achieved the autonomy they had so desperately sought. They looked to preserve that by creating their own state, but after the Civil War came more railroads, and that changed everything.

Much of the land of what was now West Virginia had been awarded as payment to soldiers and officers who fought in the Revolutionary War and other early American conflicts. Its owners often knew they held vast reserves of prized virgin timber, but they also knew they had no economically viable means for getting it to market. Then in 1873, the Chesapeake and Ohio Railway (C&O) completed its line from Richmond, Virginia, to the Ohio River—through the heart of southern West Virginia. The timber industry flourished, first along the main line, and then far beyond as branchlines and private logging railroads extended deep into the state's interior. Within forty years, loggers had cut down nearly all of the old-growth forests that had covered almost the entire state. Large-scale logging operations on second- and third-growth forests continued through much of the twentieth century.

West Virginia's vast coal reserves had yet to be fully discovered at the time of statehood. The railroads soon changed that, too. In locating the C&O along the New and Kanawha Rivers, its builders had simply sought the best route between Richmond and the Ohio Valley, but in the process they had laid their rails across some of the richest coal deposits in the continent. Over the next fifty years, the C&O built a vast network of branches into the coalfields and extended its main line to the Atlantic Ocean and the Great Lakes, becoming one of the wealthiest railroads in the country on the profitability of the coal business.

The C&O soon had a rival in the Norfolk and Western Railway (N&W). Untapped timber and coal still remained in the remote mountains along West Virginia's southern border. As coal shipments began booming on the C&O in the 1880s, the N&W built into the state from Virginia, following the winding Tug Fork and Big Sandy Rivers to the Ohio Valley. Branchlines soon fanned out to the north and south, and coal traffic swelled on the N&W as it did on the C&O. The two roads became so rich from hauling coal that, in the latter decades of the twentieth century, they set the terms in mergers with much larger railroads. Today the original C&O and N&W form the backbones of the two major rail systems in the eastern United States—CSX Transportation and Norfolk Southern.

Meanwhile, the coal business in West Virginia grew exponentially—from one million tons in 1873, the year of the C&O's completion, to 100 million tons just fifty years later. Employment skyrocketed alongside production, and the tremendous job growth in both the timber and coal industries fueled population growth all across the state. There were less than half a million West Virginians in 1873, but that number tripled over the next half century. Throughout the 1920s, nearly one out of every ten of them was a coal miner.

It is no exaggeration to say that West Virginia coal helped the United States become a global industrial power. Altogether the Mountain State has produced some fourteen billion tons of coal, roughly one-sixth of all of the coal ever mined in the United States. That puts West Virginia second only to Pennsylvania and still well ahead of Wyoming, the nation's leading coal producer since the early 1970s. In every year for more than a century, West Virginia has ranked first or second in U.S. coal production. None of that could have happened without the railroads.

The profundity of the railroad's impact on West Virginia is undeniable. Exactly what that has meant for the state, however, remains open to debate. Since hitting two million people in 1950, West Virginia's population has been in a slow but steady

decline. Coal production peaked at 182 million tons in 1997, and following a decade of volatility, dropped sharply with the global financial crisis in the late 2000's and has since shown no signs of recovering. The mining workforce peaked all the way back in 1923 at 121,000. Since then, a steady stream of technological improvements has allowed the same miner to extract ever more coal.

In popular culture, West Virginia is too often either the butt of hillbilly jokes or simply forgotten. While its collegiate sports teams sometimes make headlines, most recent coverage by the national media has concerned some form of tragedy—catastrophic flooding, rampant drug use, miners killed in an underground explosion, or drinking water poisoned by a chemical spill. Poverty levels and college graduation rates fall among the worst in the country, with household income and per capita income both ranking second to last nationally.

Railroads carried West Virginia into the industrial era, hauling its timber and coal to markets throughout the nation and around the world. Each loaded car quite literally carries away a small part of the state, and it also carries away much of the profits. With little to reinvest, the state and its residents have struggled to establish secondary industries that could have helped create a more diverse and robust economy.

The descendants of those eighteenth- and early nineteenth-century soldiers and officers—who had been paid for their service with land grants in what became West Virginia—still held legal claim to the land. Families of some of the German and Scots Irish settlers had been squatting—often unknowingly—on that land for decades, while others had been tricked into buying bogus titles. Only when the railroads made the timber and then the coal profitable did the rightful landowners send agents to announce and enforce their claims, or strike bargains for mineral rights. In some cases, rightful landowners were tricked or corruptly forced to sell. The deals took much wealth out of the state while leaving residents with deep resentment and suspicion of outsiders. To a large extent, both of those conditions persist today.

Yet through it all, West Virginians have embraced the railroad like few other people. The trains brought connectivity to the rest of the country, the goods of the modern world, and the promise of distant horizons. Today, heritage railroad operations are one of the state's three primary tourism initiatives. Preserved depots and rolling stock as well as railroad-themed festivals abound throughout the state. Most West Virginians speak quite fondly of their trains, which show up frequently in the state's rich folklore and renowned music. Much like their mountain-farmer ancestors,

today's West Virginians are proud and tenacious people. They know how to survive, they love their mountains, and they plan to stay. They take well-justified pride in their state's great role in forging America as we know it. And while few of them would dream of asking for anything in return, they deserve more than they have received.

The evidence of this long and complex relationship exists all over the state. More than 2,000 miles of active rail lines still criss-cross West Virginia, along with countless more miles of abandoned grades. Spend much time traveling in the Mountain State, and you will come to see that nearly every valley of any size once had a railroad running through it. The land shaped the paths that the railroads followed, and the railroads have been shaping the land ever since. If you want to understand the impact that railroads can have on a place, you simply have to come to West Virginia.

David Kahler understands. His photographs peer—unblinkingly and unapologetically—into the many-layered story of a complicated place and the technology that has transformed it. Kahler's approach is fearless. He is not afraid to venerate masterful works of railway engineering, nor is he afraid to highlight unsettling living conditions. Perhaps most importantly, though, he is not afraid to stop, consider,

and call our attention to the everyday, the quotidian, the seemingly mundane, "regular" places that collectively comprise the very essence of "place." Look carefully at these photographs. Like the state they portray, they contain much more to see than what at first meets the eye.

Further Reading

Williams, John Alexander. *West Virginia: A History.* W.W. Norton & Co. 1984

Lewis, Ronald L. *Transforming the Appalachian Countryside: Railroads, Deforestation, and Social Change in West Virginia, 1880-1920.* The University of North Carolina Press. 1998

Shogan, Robert. *The Battle of Blair Mountain: The Story of America's Largest Labor Uprising.* Basic Books. 2004

Cherniack, Martin. *The Hawk's Nest Incident: America's Worst Industrial Disaster.* Yale University Press. 1986

Warden, William. *West Virginia Logging Railroads.* TLC Publishing. 1996

Striplin, E.F. Pat. *The Norfolk and Western: A history.* Norfolk and Western Railway Company. 1981

Dixon Jr., Thomas W. *Chesapeake & Ohio in the Coal Fields.* Motorbooks International. 1996

Chronology

1937

Born in Harrisburg, Pennsylvania. Parent's resided in Baltimore, Maryland.

1942

Lived one year in Leominster, Massachusetts.

1943

Moved to Chadds Ford, Pennsylvania, and attended grade school for seven years. Watched steam trains double-headed by Reading Railroad camelback locomotives storm past the schoolyard where the 1777 Battle of Brandywine was fought by British and Continental forces.

1951

Borrowed my aunt's box camera to photograph Reading Railroad's Rutherford yards east of Harrisburg where my grandfather worked for fifty years as a brakeman on the hump.

1955

Entered the five-year architectural school program at Syracuse University, Syracuse, New York.

1957

Worked as an architectural apprentice in Elmira, New York. Borrowed my father's Kodak Brownie Special Six-16 camera and photographed the Southport Yards on the Pennsylvania Railroad's Elmira Branch.

1960

Graduated with a Bachelor of Architecture degree from Syracuse University. Entered graduate school at Princeton University.

1962 – 1965

Graduated with a Master of Fine Arts degree in Architecture at Princeton University. Accepted a teaching position at the School of Architecture, the University of Illinois, Champaign-Urbana, Illinois. As an Assistant Professor reorganized and taught the basic design course for freshmen architectural students. Worked part-time in an architect's office in Urbana, Illinois.

1965

Fitzhugh Scott, a prominent Milwaukee architect and one of the 10 original founders of Vail, Colorado, hired me to develop a master plan for Vail. Left Illinois at the end of the semester and worked in Vail four months prior to moving to the Office of Fitzhugh Scott in Milwaukee.

1967

Purchased a Honeywell Pentax 35mm single-lens reflex camera.

Took a five-week trip to Europe. Visited and photographed iconic architectural landmarks in England, France, Germany, and Italy. Initiated the design of the 150,000 square foot addition to the Milwaukee Art Center that was housed within the Milwaukee County War Memorial designed by Eero Saarinen. As a result, Mrs. Harry Bradley promised to give her art collection, valued at 24 million dollars, to the Art Center.

1969

Passed architectural exam and became registered in the State of Wisconsin.

1970

Became President of the Office of Fitzhugh Scott.

1971

Toured Austria, Germany, Switzerland, and France to research the design of ski resorts and other historic architectural landmarks.

1974

Fitzhugh Scott established permanent residence in Vail, Colorado. Reorganized and changed the architectural firm's name to Kahler Slater Torphy and Engberg.

1975

Opened the new Bradley Addition at the Milwaukee Art Center.

1975 – 1983

Designed the new Lincoln Memorial Bridge replacement for the Wisconsin Department of Transportation that incorporated the design features of the Bradley Addition at the Milwaukee Art Center.

1977

Embarked on a three-week European tour that included Bath and London, England, and a 2000 sea-mile Swan tour of historically significant landmarks found on mainland Greece, the Greek Islands, Turkey, and Crete, armed with an Olympus OM-1 35mm single-lens reflex camera. The tour ended with a one-week sojourn in a century's old farmhouse adjacent to the medieval town of Seillans in southern France.

1978

Elected to the Board of Trustees of the Milwaukee Art Center.

1981 – 1984

Assumed the role as lead design architect of the Haggerty Art Museum, Marquette University in Milwaukee, Wisconsin, after the untimely death of O'Neil Ford in 1982. Ford was known as the leading architect of the American Southwest.

1982

Worked with the Director of the Milwaukee Art Center to accredit the Art Center as an art museum.

1982 – 1984

Photographed The Snow Train each February at the Mid-Continent Railway Museum in North Freedom, Wisconsin.

1983

Elected to the American Institute of Architects College of Fellows (FAIA).

1983 – 1986

Served as President of the Board of Trustees of the Milwaukee Art Museum.

1990

Visited Paris, France, to study the urban lighting scene in the *City of Light*.

1992 – 1997

Made six one-week excursions in the middle of February with my wife and Leica M6 camera to photograph the Norfolk Southern Railway's Pocahontas Division in West Virginia on black and white film.

1992 – 2003

Awarded the job of working with the State of Wisconsin to restore three wings and the rotunda of the State Capitol in Madison, Wisconsin. The final product had to be historically correct in every way. Served as principal in charge.

Served as the design consultant to Rust Engineering to design the replacement of the 6th Street Viaduct over the mile and a half wide Menomonee Industrial Valley in Milwaukee, Wisconsin. The new viaduct consisted of two cable stay bridges and two bascule bridges.

1993

Received the 1993 Urban Design Award of Excellence from the American Institute of Architects for producing the Landmark Lighting Master Plan for Milwaukee's downtown Central Business District.

1994 – 1999

Awarded the job of transforming the mid-19th Century Red Gym Armory on the University of Wisconsin's Madison campus into a student center. Served as principal in charge.

1995 – 2001

Selected by the Milwaukee Art Museum to be the Architect of Record for the new addition designed by Santiago Calatrava. Made trip to Spain, Switzerland, and France to examine the built work of Calatrava.

1996

Awarded Doctor of Engineering (Honorary) by the Milwaukee School of Engineering, Milwaukee, Wisconsin.

1998

Invited to join the Board of Directors of the Center for Railroad Photography & Art that was founded by John Gruber in 1997.

1999

Awarded Doctor of Architecture (Honorary) by the University of Wisconsin-Milwaukee, Wisconsin.

2001

Transferred ownership of Kahler Slater Architects over to three co-principals.

2002 – to present

Appointed Vice President of the Center for Railroad Photography & Art when the Center became a 501(c)(3) registered nonprofit.

2004 – 2007

Served as the design consultant on the GRAEF engineering team that was commissioned to replace the old, inadequate Claude Allouez Bridge in De Pere, Wisconsin, with a new, wider structure to accommodate the increase in traffic.

2005

Moved from Wisconsin to North Carolina.

2008

Purchased digital Canon EOS 30 D camera.

2013

Trains Magazine, online, published my photo story, *Stalking Coaling Towers in Maine*. October 31, 2013.

2015

Made a 40 minute presentation, The Railroad: The Art of Place, at the Center for Railroad Photography & Art, "Conversations on Photography" conference, Lake Forest College, Lake Forest, Illinois, April 11, 2015.

2015 – present

Continuing my quest to photograph remnants of railroads and industrial detritus that contribute to the art of place found in the American landscape.

2016

Published short essay with three photographs of old freight house in Sanford, North Carolina, that appeared online in *The Trackside Photographer*, June 9, 2016.

List of Plates (all photographs in Kentucky and West Virginia were made between 1992 and 1997)

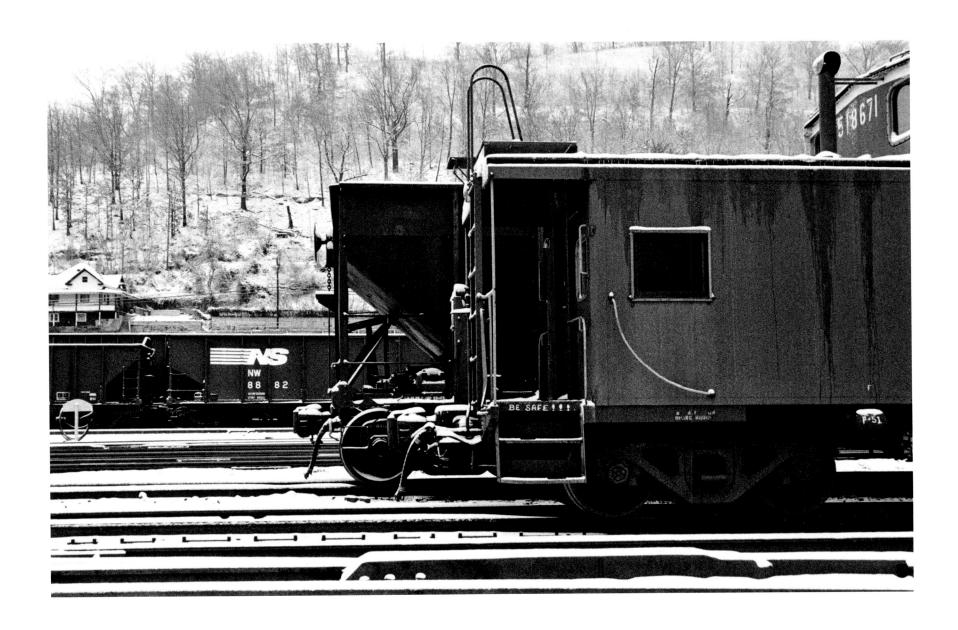

About the Center

Founded in 1997, the Center for Railroad Photography & Art is a 501(c)(3) national nonprofit arts and educational organization based in Madison, Wisconsin. As its mission the Center "preserves and presents significant images of railroading," interpreting them in publications, exhibitions, and on the Internet.

The Center conducts its programs in-house and collaborates with numerous partners throughout the country as evidenced by the recent Chicago History Museum exhibition, "Railroaders: Jack Delano's Homefront Photography." The Center also mounts traveling exhibitions by individual photographers such as Joel Jensen, O. Winston Link, David Plowden, and Jim Shaughnessy.

Efforts to preserve railroad photography and artwork have led to the Center's amassing some 200,000 images. The Center conducts its preservation activities both in-house and with the Archives & Special Collections of the Donnelley and Lee Library at Lake Forest College in Lake Forest, Illinois.

The Center publishes a quarterly journal, *Railroad Heritage*, featuring work by historic and contemporary photographers and artists. The Center also hosts an annual conference at Lake Forest College each year in the spring where artists, historians, editors, and railroaders discuss their work and address photographic and artistic issues. Visit the Center at www.railphoto-art.org.